SKIPTON & THE DALES

THROUGH TIME

Ken Ellwood

Ken Ellwood

AMBERLEY PUBLISHING

First published 2011

Amberley Publishing
Cirencester Road, Chalford,
Stroud, Gloucestershire, GL6 8PE

www.amberley-books.com

Copyright © Ken Ellwood 2011

The right of Ken Ellwood to be identified as
the Author of this work has been asserted in
accordance with the Copyrights, Designs and
Patents Act 1988.

ISBN 978 1 84868 562 8

British Library Cataloguing in Publication Data.

A catalogue record for this book is available from
the British Library.

Typeset in 9.5pt on 12pt Celeste.
Typesetting and Origination by Amberley Publishing.
Printed in the UK.

Introduction

This, my sixth book on Skipton, is different in that I have included some of the Yorkshire Dales, hence the name *Skipton and the Dales Through Time*.

This new title allows me to use some of my collection of aerial views, all taken during the time I took up flying again after the Second World War. Until now, with their inclusion in this new book, I had offered many of these images to publishers of magazines and other small publications.

My first attempts at aerial photography were at No. 3 British Flying Training School, Miami, Oklahoma in 1943. The very first aerial photograph I took was of the Palo Duro Canyon, in the pan handle of Texas, during a very long cross country flight.

My first efforts were from the Tiger Moth, using a Zeis Contaflex (seen here in this book). Later, I used the Hasselblad, a larger format camera, with which I could make and mount transparencies and give slide shows.

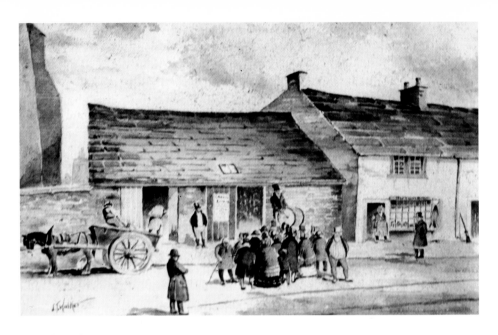

The Old Tithe Barn

In its later years it was used by travelling showmen and salesmen. It was demolished in 1901 to make way for Mr A. Stockdale's Wine & Spirit Lodge. Originally it had a thatched roof, but this was removed in 1750, when it was re-covered with stone slates by Mr Thornton (a founder of R. Thornton & Sons – slaters who closed their business a few years ago). This colour picture was made just before the barn was demolished.

Here is the building that replaced it, standing next to a building which was the vicarage for Christ church.

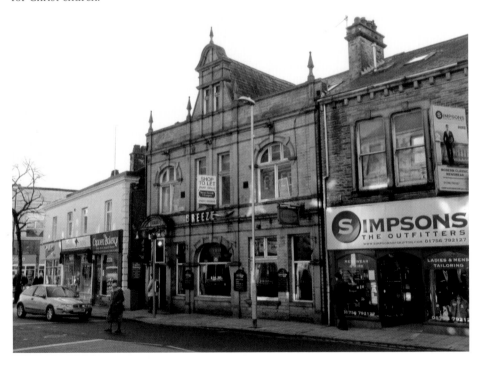

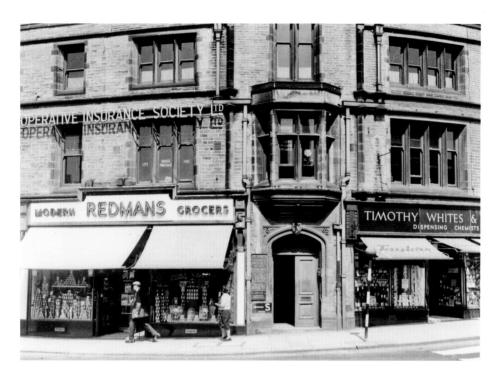

Ship Corner

Here is the old Ship Hotel and to the right is the way into Caroline Square. The old image was taken about 1950, and is interesting because the air-raid shelter sign is still to the left of the door. Step inside the door and one can see the mosaic floor which reads 'Ship Hotel'. Notice the change of shops since 1950 in the new image.

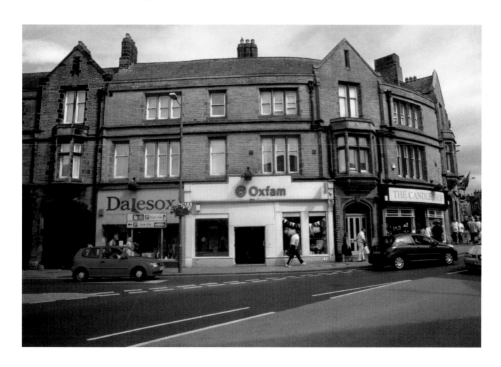

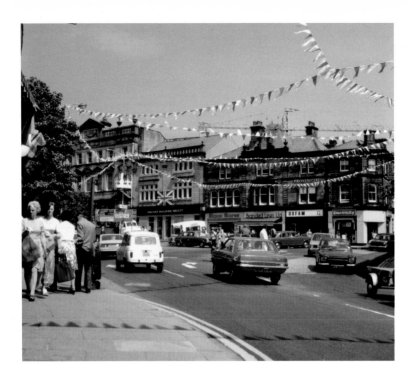

Through to Caroline Square

Here is a festive lower High Street in celebration of the Queen's Silver Jubilee. Simon Stores, Branded Lines, Oxfam, and Electricity have all changed. Below is Caroline Square in 2011.

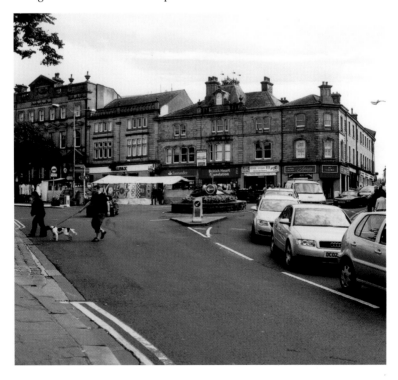

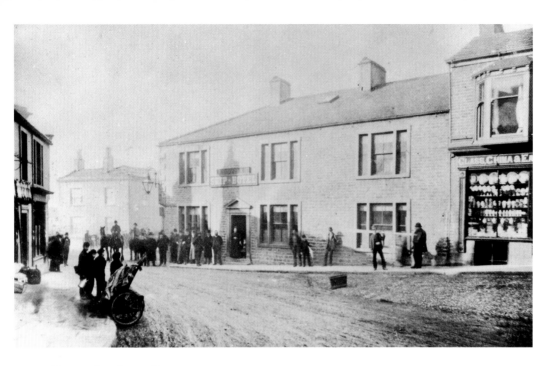

Ship Hotel and Caroline Square

This is the original Ship Hotel, which was demolished in a road-widening scheme in 1888–90 to improve the narrow Ship Corner – Francis Addyman was landlord from 1885–8. The glass, china and earthenware shop on the right was owned by Mr Porri.

Caroline Square looks enormous without the roundabout. Wilson the saddler occupies the part of the building that is now Dollands. Later Bryan Hargreaves had his dental surgery above this shop, and in 1961 I took over from him, remaining in residence there until 1986.

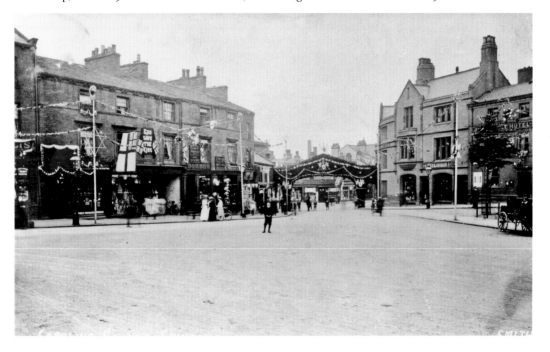

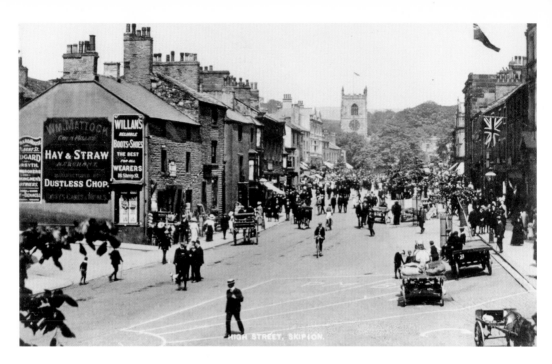

Whit Walk

A busy scene in the High Street before the Whit Walk started. The chalk lines show where the different religious groups assembled – on the left 'PM' marks the spot where the Primitive Methodists assembled.

Years later all the groups are mingled together – this looks to be in the 1920s. A lorry belonging to Claytons can be seen up the High Street.

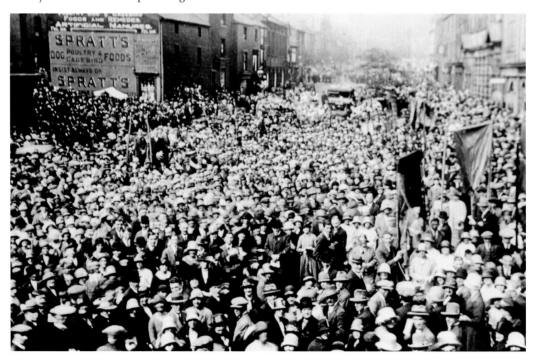

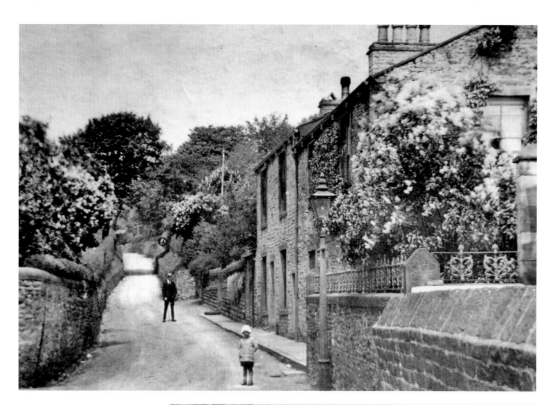

Rectory Lane
I always look on this as a country lane within Skipton and I hope it is allowed to stay as it is. The image, going by the dress, is most likely Victorian.

The colour picture is taken from further up the lane. Otley Street School was near here and Mr Carrington the headmaster once remarked to me how he enjoyed the changing scene during the seasons.

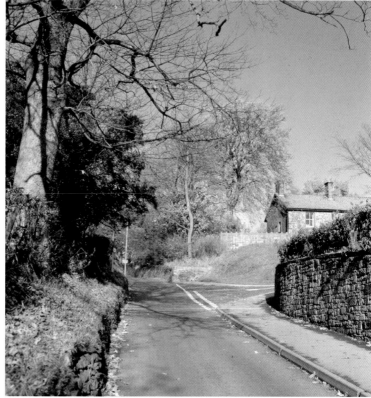

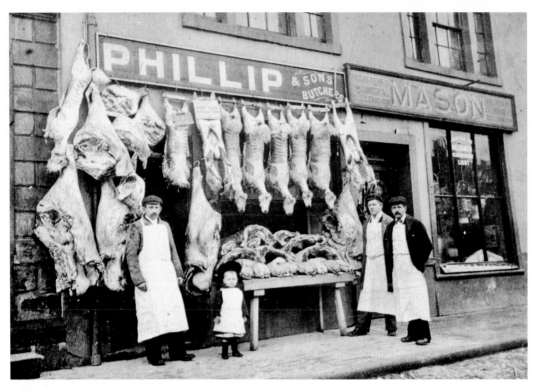

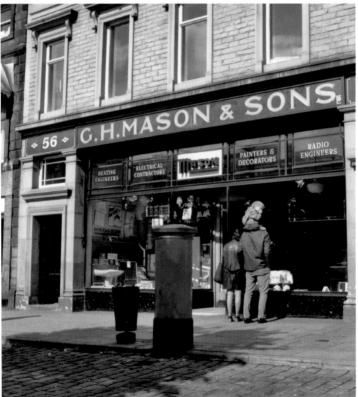

Phillip & Mason
Phillip the butcher and G. H. Mason the plumber occupied these shops on the site of the old Black Bull Inn, later the Sun Inn. The shops were demolished and rebuilt for G. H. Mason & Son in 1928 – they are now occupied by Boots Chemists.

Here is G. H. Mason before they closed. Many of the skilled employees set up in business on their own and did very well.

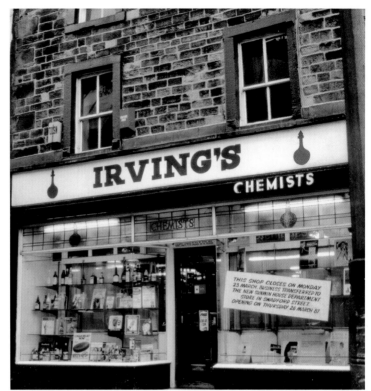

Irving's Chemists
Located in Sheep Street this was a busy shop. When I worked nearby, the manager was Mr Ackroyd and May was his assistant. Inside the shop there were lots of traditional small mahogany drawers, where drugs had been kept in times past.

This is a photograph of the same building in December 2010.

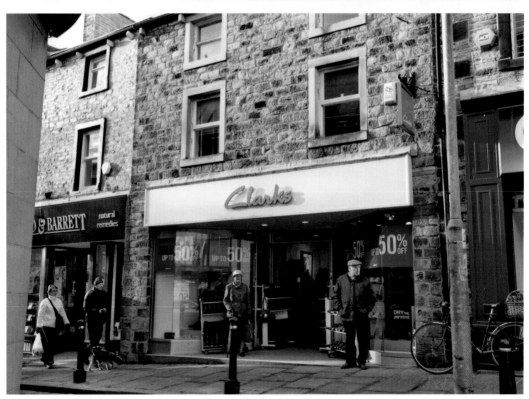

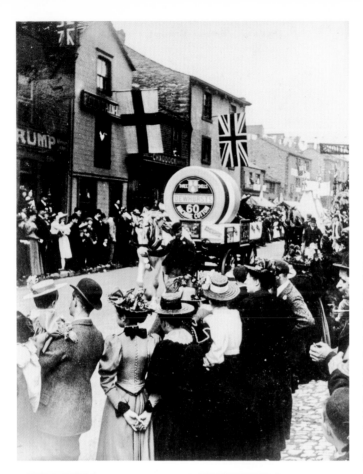

Skipton Gala
This is an Edwardian scene, showing how at the time the Skipton Gala parade passed down the High Street towards Caroline Square. Note the splendid float representing Dewhurst's Sewing Cotton Company. A large bobbin is hauled along by one of the company's cart-horses.

It's a very different scene today.

Providence Place

Providence Place in the 1920s/1930s. Mr and Mrs Davies who loaned me this picture lived here and described this street as 'good town houses'. They were demolished to make way for Skipton Building Society.

Still called Providence Place, the right of way is preserved and is only a short distance from Newmarket Street.

The new buildings, which are very high for an old town like Skipton, are now dissused or to let.

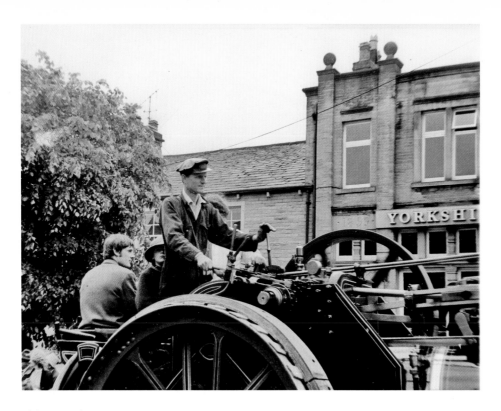

Skipton Gala, *c.* 1970
This is my Burell traction engine leading the parade. I am driving and Ted Mell is steersman.
The support is Jim Turnbull and Peter Ellwood, and we are opposite the Yorkshire Bank.

In 2010, my grandson Angus Ellwood was in the parade with Embsay Junior Football
Club.

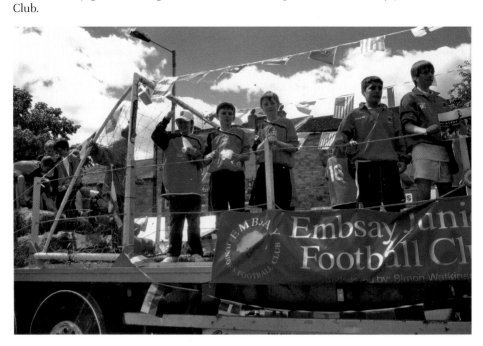

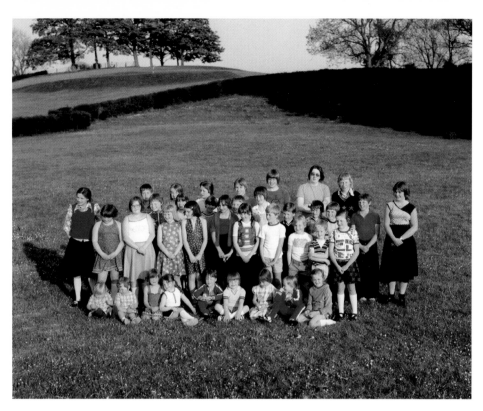

Skipton Swimming Club

Sometime in the 1970s, Donald Thornton of Skipton Band asked me to photograph the Skipton swimming club juniors, so here they are next to the then-new swimming pool.

The parade of 2010 also had a float with the present swimming club.

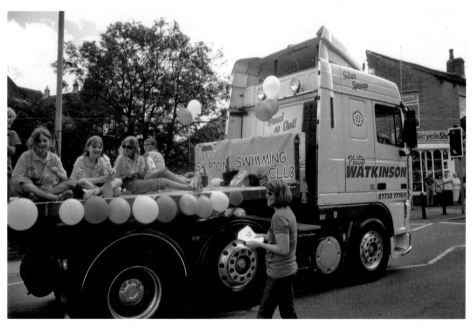

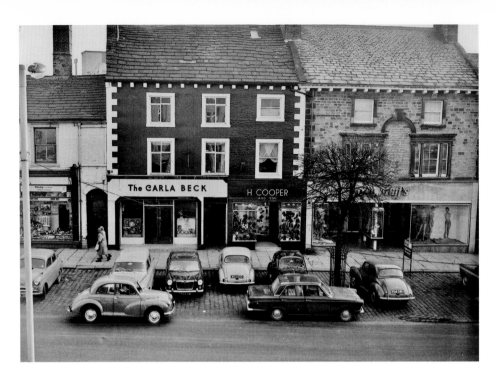

The Carla Beck Milk Bar
Many Skipton people have fond memories of this place, which was quite a novelty at that time (*c.* 1950s). Here is the scene today, 2010.

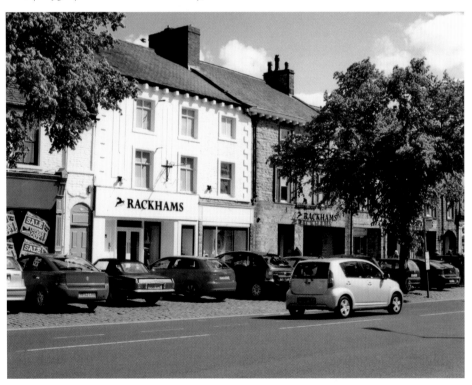

Aerial Views of Holy Trinity Church and Skipton Castle
This view shows the ditch that runs through the field, which is thought to have been part of the castle moat.

In this view the Castle grounds and wall can be seen to their full extent, including the garden and jousting area.

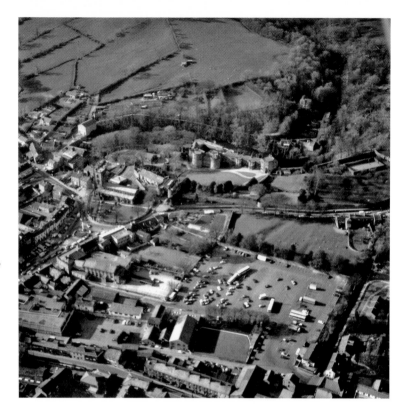

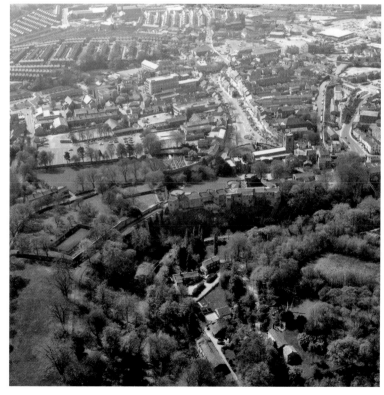

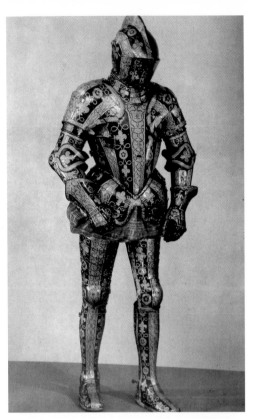

George Lord Clifford, Third Earl of Cumberland

Born in 1558, George Lord Clifford was very adventurous at sea and is worthy of further reading. On the front of his hat he wears the glove of Queen Elizabeth I to show that he is her champion.

His splendid suit of armour was made by Halder at the Greenwich armouries. Halder was brought over from Germany by Henry VIII to take charge of these armouries. It is worth a trip to New York to see it in the Metropolitan Museum of Art.

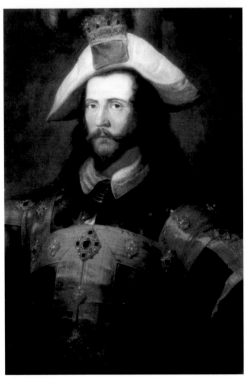

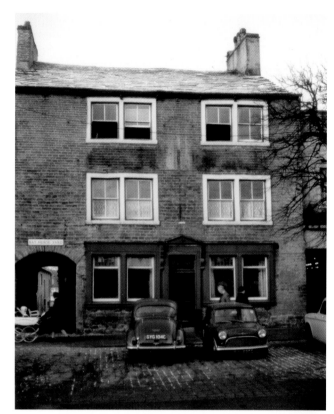

Kings Arms
This pub was part of Skipton's High Street, but was demolished to make way for the shops seen here sometime in the 1960s.

Below is the scene in the 1980s.

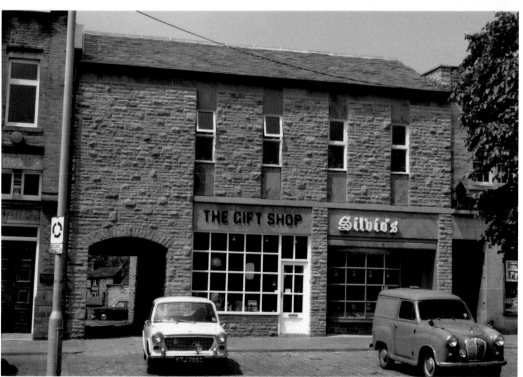

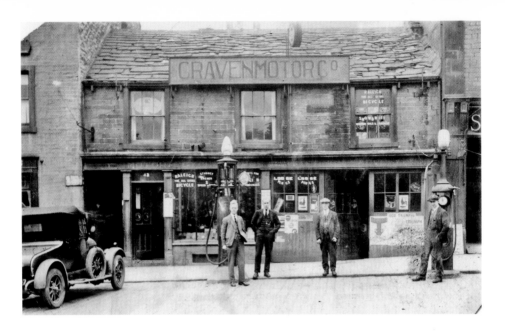

The Craven Motor Company Ltd

This garage also stands on the High Street, and was successful for many years between the wars. It was between the Red Lion and the *Craven Herald*, and one can see how the building was altered over the years.

There is a lot of interest for the motor enthusiast in the various signs, such as Talbot – who had not yet joined Sunbeam. Donald Smith, who loaned me the old picture of the top of town, worked at the garage (but after these photographs were taken) and knows a lot about the other branches in the town.

Peter Watson, who has a garage in Otley Road thinks that the two gentlemen standing between the premises are Mr Angus and Mr Ratcliffe.

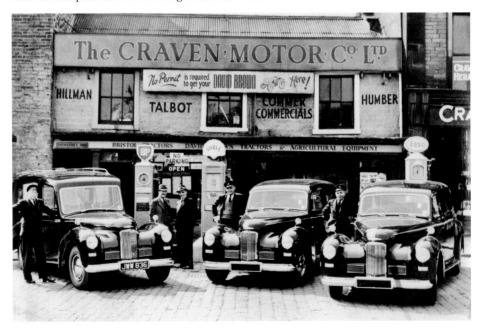

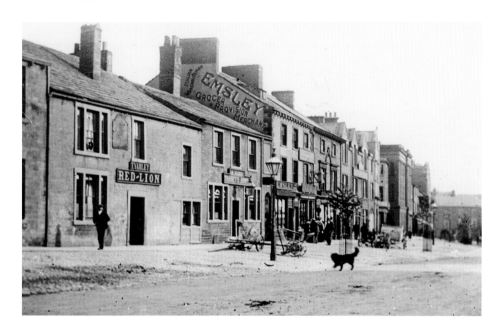

The Red Lion Inn

One of the oldest inns in Skipton, the Red Lion is still serving the public. It is reputed to stand on the site of the former hospital of St Mary Magdalene, a leper hospital from 1310–50. It is said to have been an inn ever since.

The Red Lion in 2010.

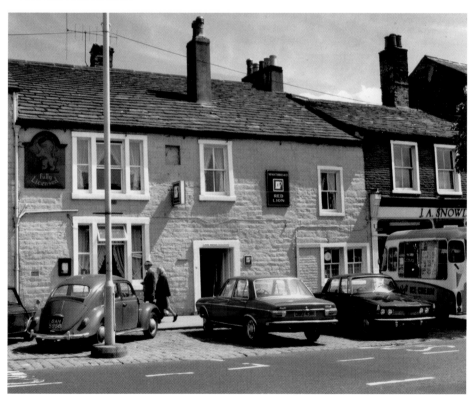

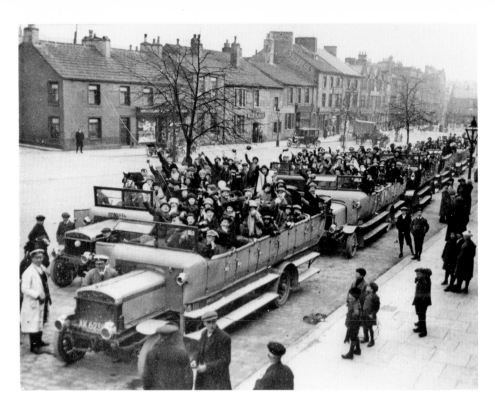

School Trip

These eight charabancs appear packed full of children, and they know they are being photographed! The car outside the Red Lion looks like a Model T Ford. Contrast with the view in autumn 2010.

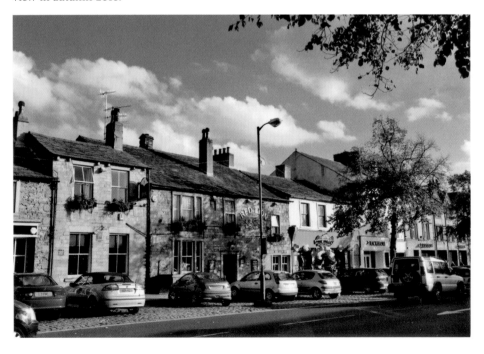

The War Memorial

A memorial made of wood was erected at the top of the High Street after the removal of the statue of Sir Matthew Wilson made the site vacant. This was only a temporary memorial, until the real one could be constructed.

A model of the original one was made by the D. Cassidy Studio, Lincoln Grove, Manchester.

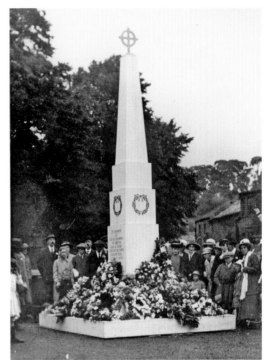

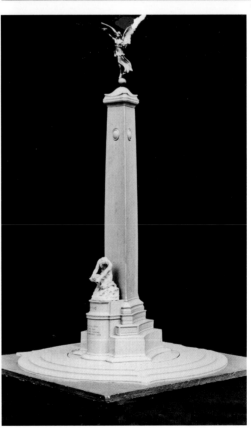

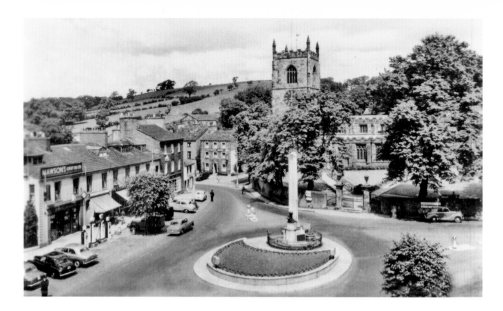

The Cenotaph and Parade

A post war scene showing the Cenotaph at the head of the High Street and in front of Holy Trinity Church – Mawsons garage can also be seen.

Skipton band are on parade and playing in front of the Cenotaph. Ken Bright is conducting and John Preston has the big drum, two stalwarts of the band and now sadly deceased.

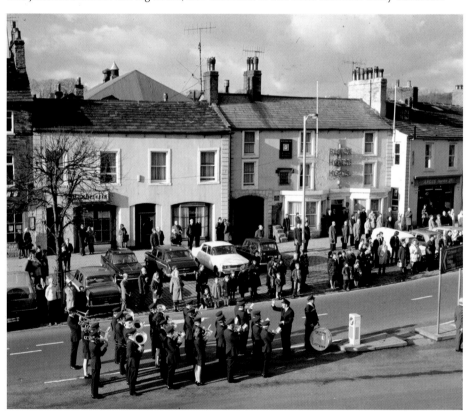

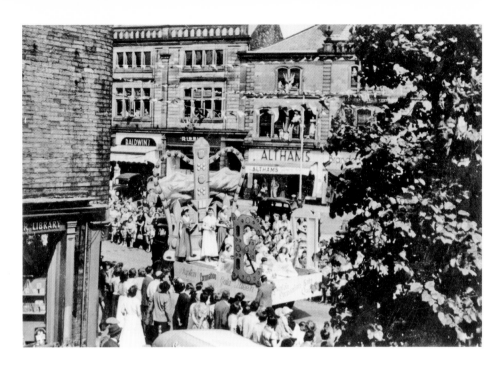

Coronation Gala Parade

George Prochock, a displaced man from Ukraine, took this picture from a room in the Brick Hall, now the Woolly Sheep. He and I lodged here in 1953 and were well looked after by Mrs Burke and Norah, who still lives in Skipton.

Later, in about 1969, I was able to lead the Hospital's Gala Parade. Jim Turnbull was steering the Burrell traction engine and Peter Ellwood came along for the ride.

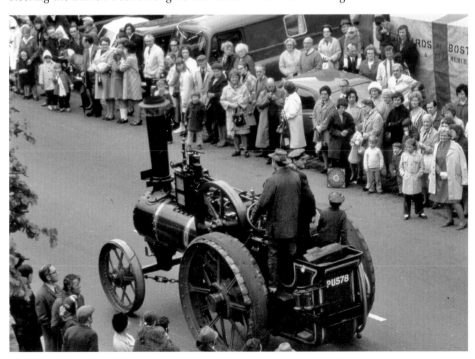

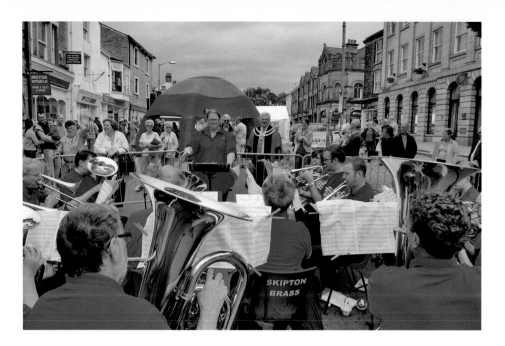

Skipton Band

After many years of hard work, which included much publicity and appeals to young people to join the band and learn to play a brass instrument, a full band was formed.

Many people have to be thanked for this including; the Ladies' Committee, whose hard work produced a Cornet; the doctors and dentists, who presented a trombone; and the Mechanics' Institute, who called me to a meeting and donated £1,000 to purchase a new Bass. There were many more such donations.

This was an inspiring time for the band members, who had worked so hard and even won their way to the National Brass Band Championships in London. Here is the band with new uniforms, with J. K. Ellwood as president and Maurice Powell as conductor.

The band today, still working hard and providing a place for young people to learn to play an instrument.

Forty years ago I said that Skipton should have a centre where all societies of Skipton could meet in comfort, but this has not happened. The band have always had to move around. I will leave the reader to think about this, perhaps a place could be considered in the plans for the old Health Centre.

This picture was taken by Mark Santos, who is with the Skipton Town Council.

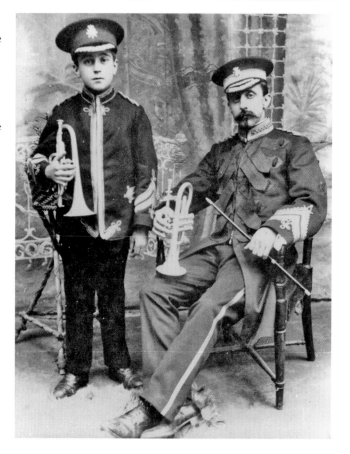

Fred Metcalfe

The gentleman conducting the Skipton Band at our garden party is the young man in the older photograph, standing with his famous father who was a tutor and bandmaster for sixty years. 'Young Fred', as he was known, served the band well and even in his retirement helped me a lot when, as new president, I was helping to rebuild the band. He was always ready with advice and donations, and indeed when he died he left £1,000 in his will to band funds.

This garden party was an annual event held at our home in aid of band funds and was organised by the Ladies' Committee.

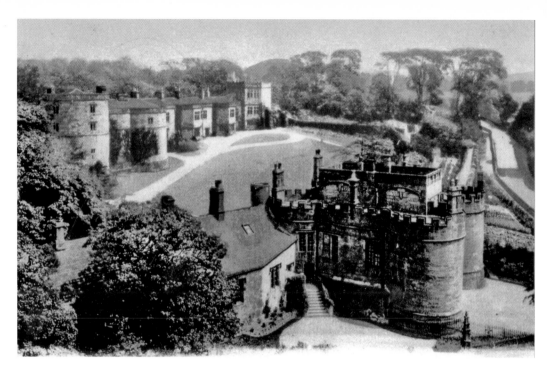

Skipton Castle

A view taken from the church tower. This is copied from an old postcard, which has been tinted. The road out of Skipton to Embsay is on the right and is always busy with pedestrians showing how fit the Embsay folks are. Another view taken from an artist's impression.

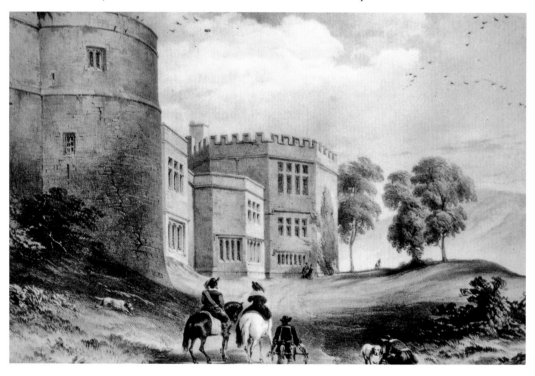

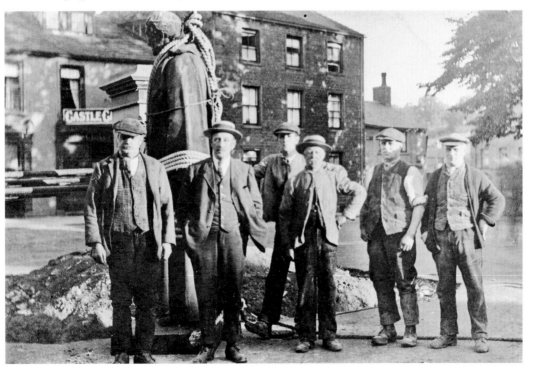

Sir Matthew Wilson

This statue of Skipton's first MP lived at Eshton Hall and is unusual in that it was erected during his lifetime. It was unveiled in 1888 by the Marquis of Ripon.

The statue was moved in 1921 to make way for the new Cenotaph. B. B. Kirk was the contractor and his business was on Waller Hill. The bus station is there now.

Here is Mr Kirk, wearing a straw hat, with M. Baynes, J. Baynes, and two unknown men. They stand as if there is nothing unusual, but poor Sir Matthew is hanging on the end of a rope.

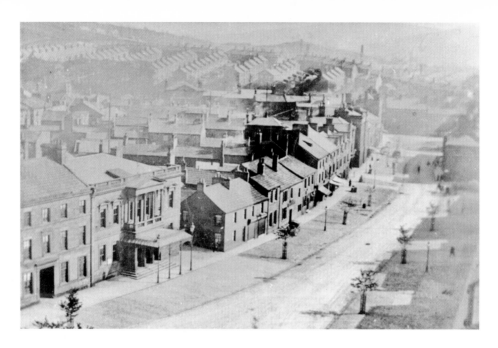

High Street from the Church Tower

This picture was taken later than 1897, because the trees were not planted until that year. Dobson the chemist is the only shop, in the building at the corner of the road, next to the town hall. This road leads to Jerry Croft, where the Cattle Market moved after they were ordered off the High Street *c.* 1911.

 The next picture is much later. We can see motor cars and also the café, situated next to Dobson the chemist.

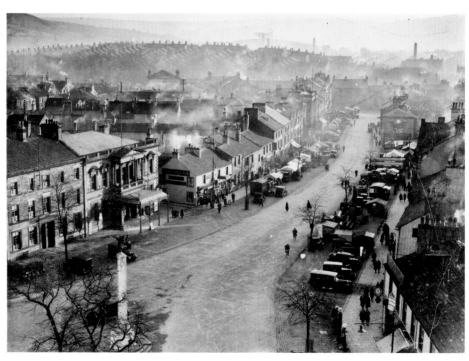

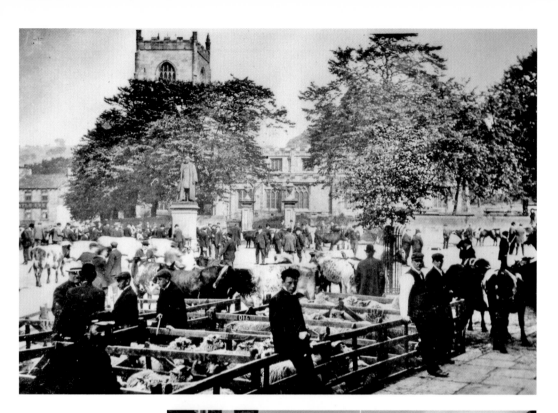

Cattle Fair at the Top of High Street
Here the cattle are allowed to be loose in the High Street but the sheep are kept in pens, otherwise they would roam all over the place.

About eighty-three years later these fairs were re-enacted, but in these days there had to be more control, and as such all the animals had to be kept in pens. This was a good effort by the farmers involved and as you can see some of the original breeds were on display.

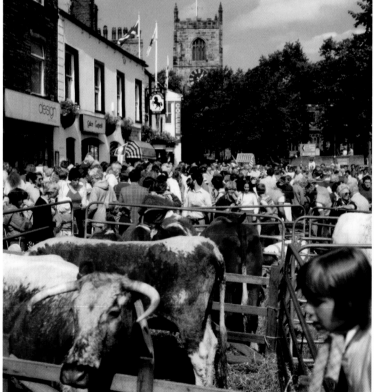

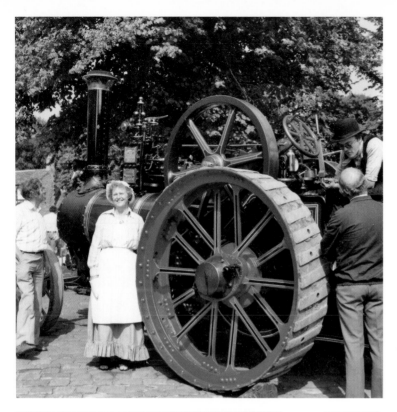

Medieval Fair in Skipton, 1983
Here, in the summer of 1983, Kath appeared with some food and drink for the engine men, and I asked her to pose for this photograph. Alwyn Rogers, who was a valuable member of the crew, is explaining the workings of the engine.

Back on the Soroptomists stall, she is helping serve refreshments. Other Skipton Society's were also in the High Street and a good day was had by all.

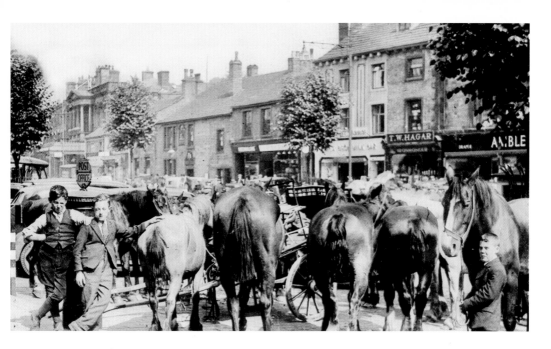

Horse Fair

Skipton's annual horse fair was on the decline when this photograph was taken in the early 1930s. It was held in August following hay-time, when the farmers wanted to buy or sell their horses. Some of the horses in this picture, known as 'July Razors', were owned by Miller family of Skipton.

Not quite the same scene today.

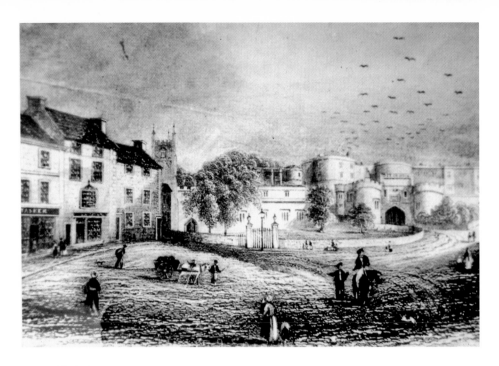

Upper High Street

The upper part of Skipton High Street about 1840. Tasker's shop (later the *Craven Herald*) is seen on the left and is now Thorntons chocolate shop.

Skipton's first gas lamp 'Old Gormless' stands in front of the church gates. Skipton castle looks majestic.

The library on the left, opened in 1897, helps to date this old postcard, which shows a party of ladies setting off for a trip in a charabanc, a very popular transport at the time.

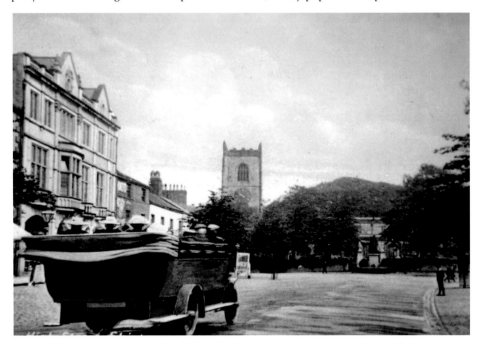

Steam Trip to Long Preston

In the 1970s we attended two or three steam parties at Long Preston. One in particular helped the village to raise money to help in the renewing of their village greens which had been concreted over.

Frank Fattorini came out to see us off, our engine shed was next to 'Ways Meet' where he lived.

Our steersman that day was Mr Smith of Northumberland, who owned a fleet of steamrollers. His daughter lived in Hellifield and we are in a layby there for a cup of tea. Also in the picture is the support team, sons John and Peter and my wife Kathleen.

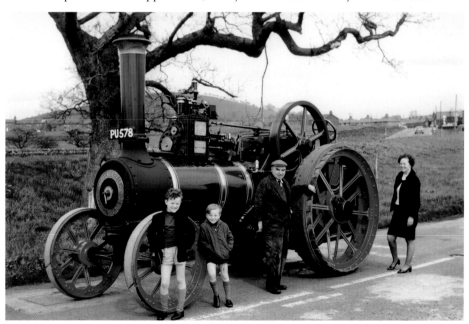

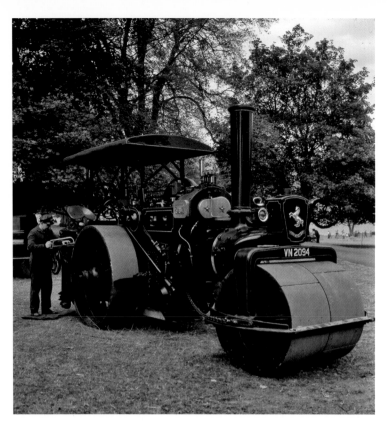

Steam Roller

This Aveling & Porter roller belongs to a friend of mine who now lives in the Lake District. He and I attended the Country Fair at Coniston Cold, held by Mr and Mrs Bannister, and Stuart is on his way home to Denholme.

He also has a road locomotive, which he drove over Hardknott pass. He had to descend in reverse, otherwise the crown of the firebox would not have been covered with water and therefore would have been damaged.

Note the shops, this time in 1973.

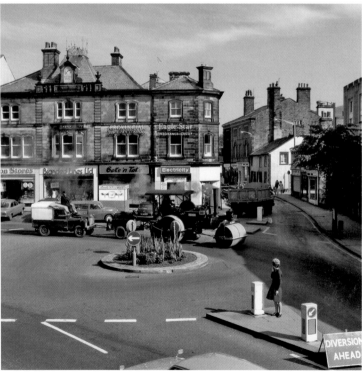

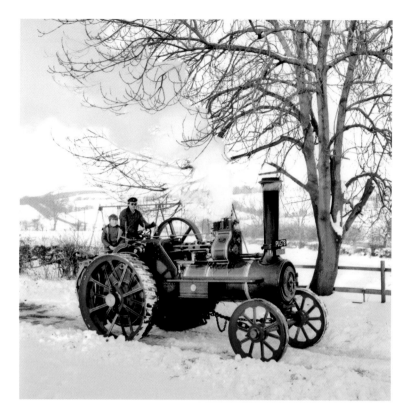

Christmas 1981
Despite the extremely cold weather we were able to turn out with the Burrell traction engine to bring Father Christmas to Skipton Town Hall in a parade organised by the Skipton Round Table. Here is Alwyn Rogers and a young Kershaw. Father Christmas is greeted by clowns!

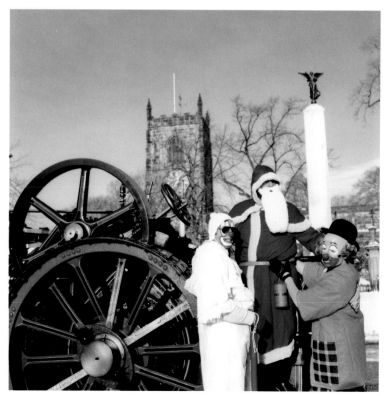

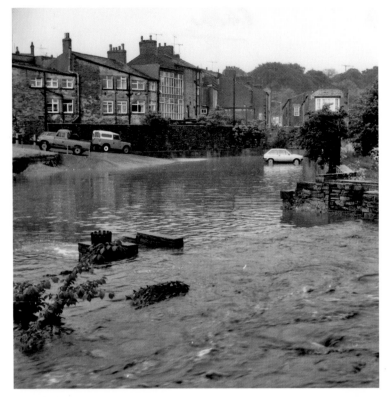

Skipton Flood 1979
Water poured into Skipton from all directions and at this point along Water Street the canal overflowed into Eller Beck, which runs alongside it, and over into the drained mill dam, which was being used as a car park. Later I was surprised to see new houses appearing around the perimeter, but with garages underneath – no doubt in case there was another flood.

Jack Ward, Blacksmith

Jack was the last working blacksmith in Skipton. His smithy was at the bottom of Raikes Road and is now occupied by the Wright Wine Co.

I passed the smithy everyday on my way to work and took this photograph in 1972. It was published in *This England* magazine. Our son John remarked it was like an oil painting.

Here is the smithy as it is today.

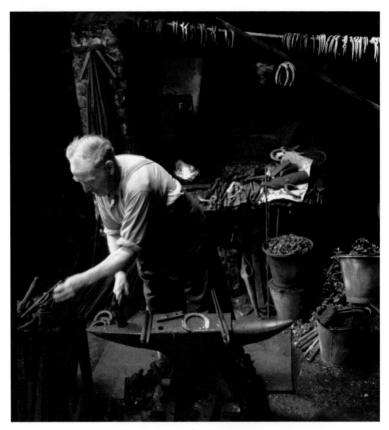

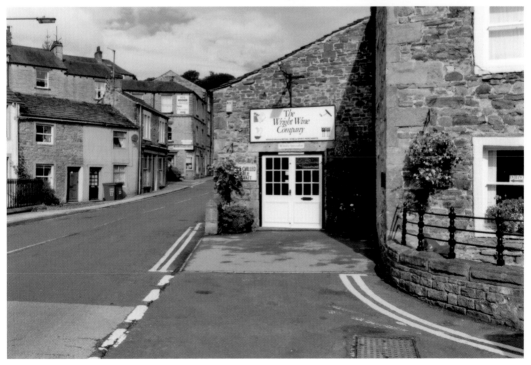

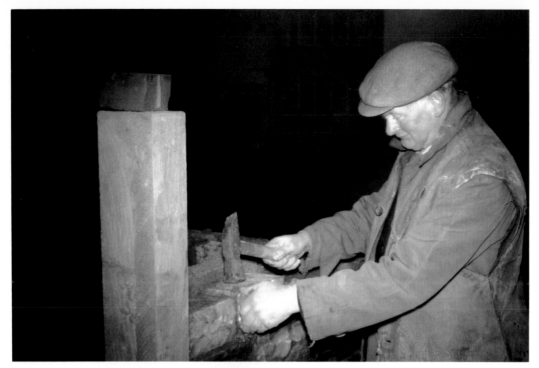

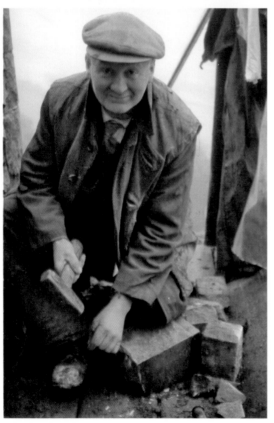

Thomas Stephenson, Stonemason
Tom Stephenson was another skilled workman in Skipton and is seen working on the extension to my house. He was a mason with prodigious skill in laying the stone, or 'walling' as he called it. He took all his tools to Jack Ward to be sharpened and tempered. He worked for Chapman's the builders and has many tales about working all over Craven. He is now ninety-seven!

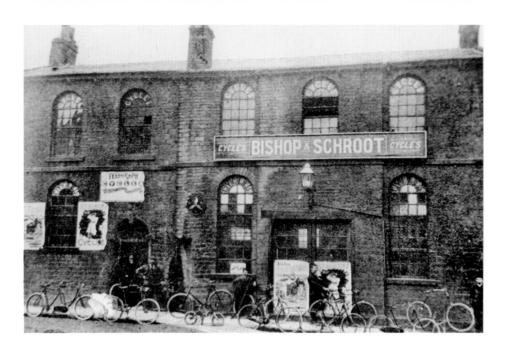

The Hair and Beauty College

This was the first Primitive Methodist chapel, from 1835–80, and it later housed Bishop and Schroot's cycle shop. Later it was the fire station, before being renovated and becoming the college of Hair and Beauty, which it still is today.

Property around this area, such as Lower Commercial, was demolished and there is a car park on the site, still known as the fire station car park.

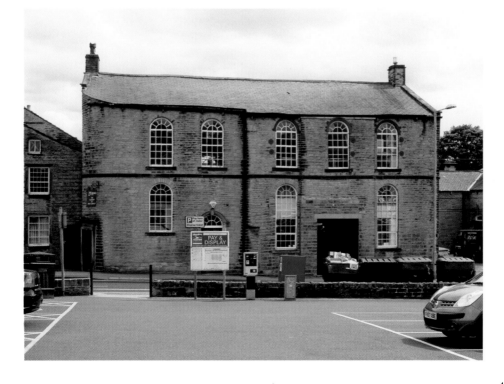

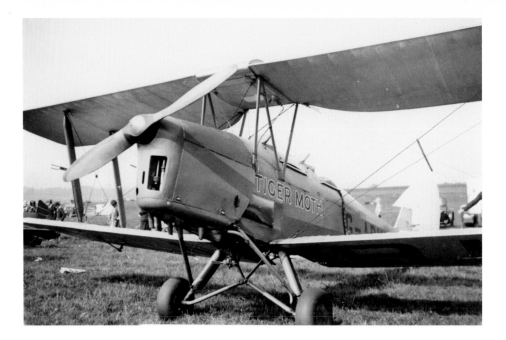

Tiger Moth at Skipton

This Tiger Moth was part of Sir Alan Cobham's Flying Circus, which came to Skipton in June 1932 and gave a display down at Sandylands. On occasion they asked the farmer if he would demolish a wall to give them a longer take off run.

I have spoken to many local people who paid for a flight round Dewhirst's chimney. Sir Alan addressed the Rotarians and said every town the size of Skipton should have an airfield.

In the modern picture, I am coming into land at Breighton near Selby in the year 2010. I actually flew this Tiger Moth when I was in the RAF at the end of the Second World War. I purchased it in 1994.

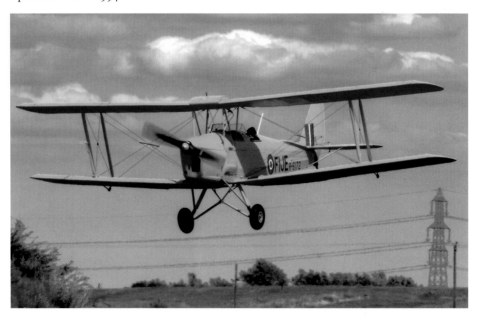

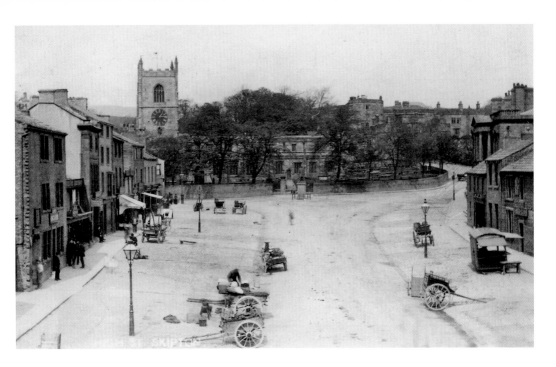

Skipton High Street

Donald Smith and his wife Anne of Victoria Mill loaned me this very early photograph of Skipton, which can be dated by the fact that the statue of Sir Matthew Wilson – erected in 1888 – is present and the trees – planted in 1897 – are not.

Compare this with a similar picture – post 1897 – which shows the trees and the *Craven Herald* and printing works sign. In about 1875 the print works were in a building called Staffordshire House at lower Sheep Street.

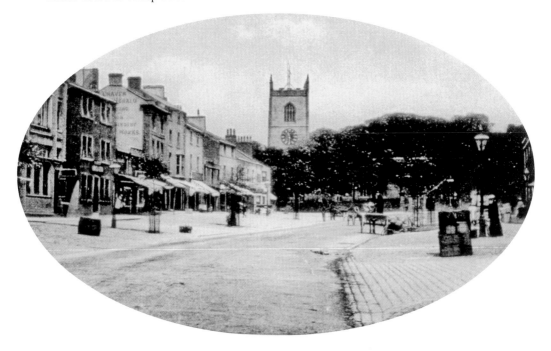

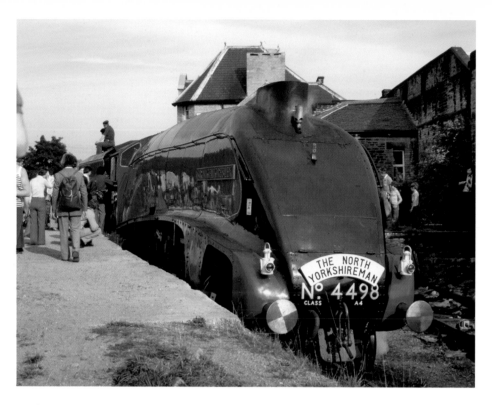

At the Station

During the 1980s steam tours to Carlisle left Skipton every Wednesday, returning the same day. Seen here, waiting in the horse dock is 4498 *Sir Nigel Gresley*. Caught by camera crossing the River Aire is the return journey.

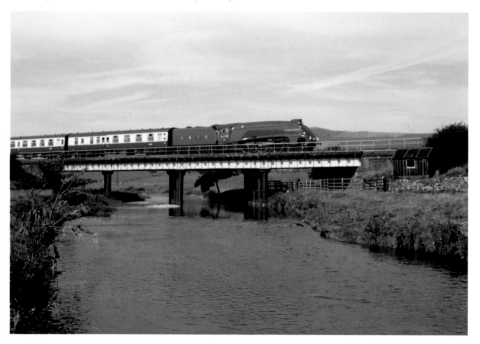

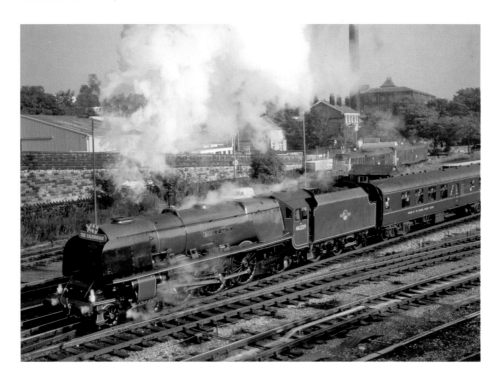

Duchess at the Station

Here is 44629 *Duchess of Hamilton* leaving Skipton on a tour to Carlisle. Dewhirst's Mill chimney can be seen through the steam – it was demolished a few years ago.

Earlier, we see a very old locomotive, *Hardwicke*, from York Railway Museum, double-heading the *Flying Scotsman* and a support coach after taking a tour to Carlisle.

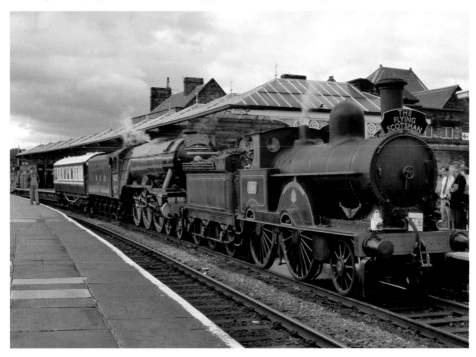

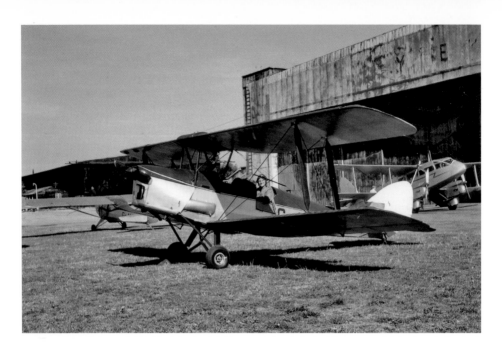

Tiger Moth G-APCU

My first flight up Wharfdale was in June 1959 and I used Tiger Moth G-APCU, which was one of three used by the Yorkshire Aeroplane Club based at Yeadon Aerodrome, which is now Leeds–Bradford airport.

Here is the Tiger standing in front of the old hangar with a D. H. Rapide standing inside. Within ten minutes I was in the air and heading for Grassington, complete with camera.

Soon after takeoff I spotted this ring near the village of Addingham, which can be seen on the photograph between the wires. It is an early fortification, perhaps Romano–British period.

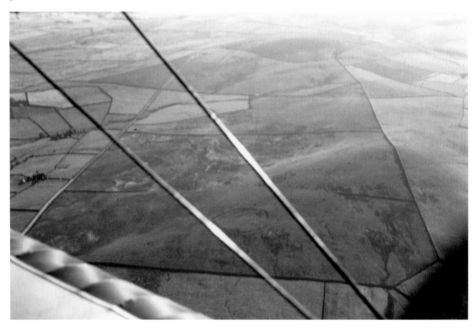

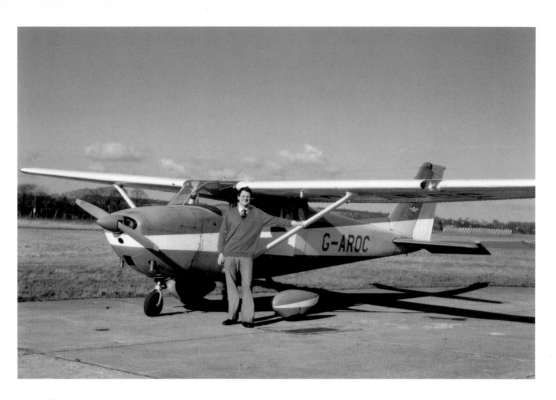

Cessna 172

A few photographs taken from the Tiger Moth are shown later, but I would like to introduce the Cessna 172, which was flown on later photographic missions.

In 1960 G-APCU was sold and one crashed into a large pond, which is now a car park.

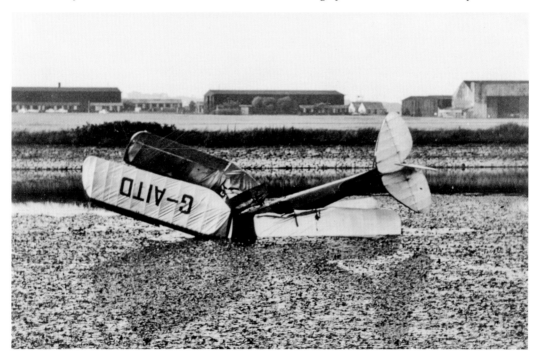

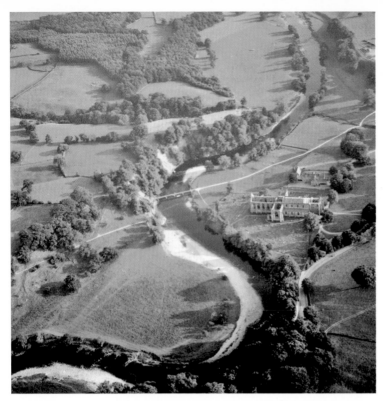

Bolton Priory
Work on the entrance into the Priory, which had begun in 1520 but was abandoned in 1539 due to the Dissolution of the Monasteries. This is clearly seen in the aerial photograph, which was taken about 1978.

The next picture shows the entrance tower restored and the roof complete. The work was completed in 1984. Neil Hartley was the architect.

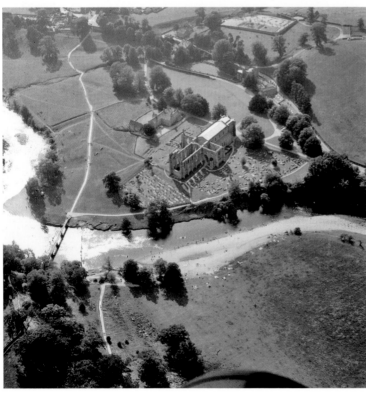

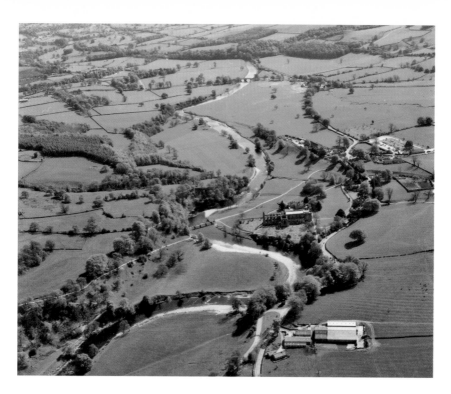

A General View

A lot of the area can be seen from this viewpoint, note in particular the village of Bolton Abbey, with the track leading down to the River Wharfe, the footbridge, and the stepping stones. There are many good walks from here, going both ways, and indeed this is part of the Yorkshire Dales Way, which starts in Ilkley and finishes in the Lake District.

Look down the valley towards Ilkley and note the beautiful bridge carrying the road from Skipton to Harrogate – now by-passed by a modern bridge.

Here is a recent view of this valley from the old bridge looking towards the priory.

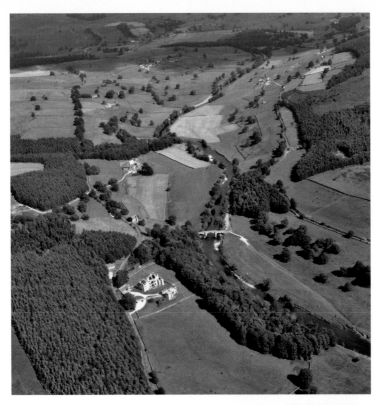

Barden Towers, 1993
Barden Tower is described by Nikolaus Pevsner in his book *Buildings of Britain* as an 'impressive tower house at the time of Lord Clifford the Shepherd Lord, which is at the time of Henry VIII [1509–47]'.

Lady Anne Clifford restored the building in 1658–9. Pevsner describes the position in Wharfdale as 'Exquisite'.

The modern photograph depicts the Skipton band marching past Barden Tower. They were on their sponsored march through thirty villages to raise money for the future of the band.

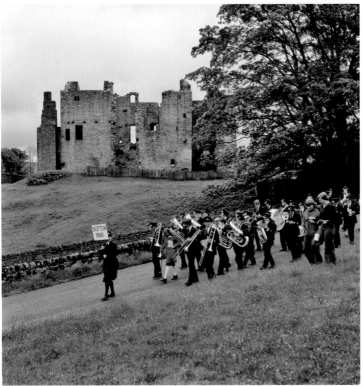

Appletreewick
A short flight up the valley will bring us to Appletreewick, a lovely village built on a hillside. The white building at the bottom of the hill is the New Inn – at one time Yorkshire's only no-smoking inn – and on the far left is the Craven Arms. Since this photograph was taken the owner has built a Cruck Barn using local labour.

The Skipton Band have also arrived and no doubt have enjoyed the downhill section!

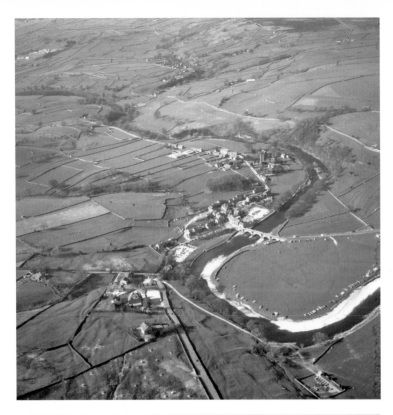

Burnsall

Within a minute we are over Burnsall and a bend in the River Wharfe, which is quite spectacular. You can also see a beautiful bridge, built in the late nineteenth century to replace one which was destroyed by floods.

The twelfth-century church is at the top of the village. Beyond sits Hebden and the high, level road known as the 'Scuff Road', from where there is a superb view of the village.

The Wharfe View Tea Rooms provide good food and are well used by 'Dales Way' walkers. The young farmers' wives provide freshly cooked food on the spot.

The band passing the Red Lion Inn.

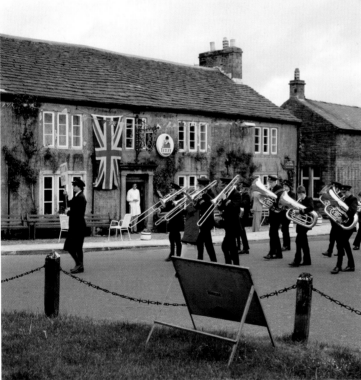

Thorpe

A tiny village or hamlet, Thorpe is surrounded by reef knolls. It is so hidden away from the nearby roads that it was never found by Scottish raiding parties.

Above is the grouse moor owned by the Duke of Devonshire. Below there is evidence of many ancient field systems.

The reef Knolls are made of almost pure limestone from seashells, there is a large quarry nearby. Some years ago a quarryman, by the name of Mr Bentham, gave me a fossilised piece of bamboo, it is now in the Craven museum in Skipton.

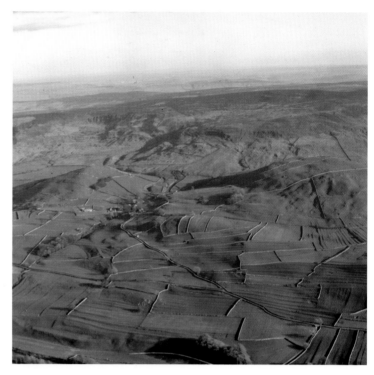

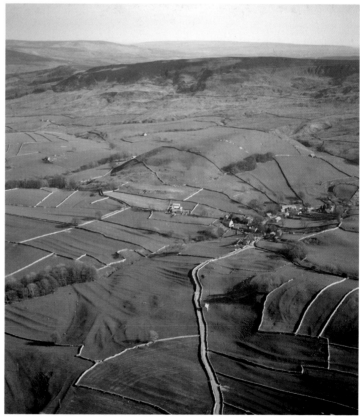

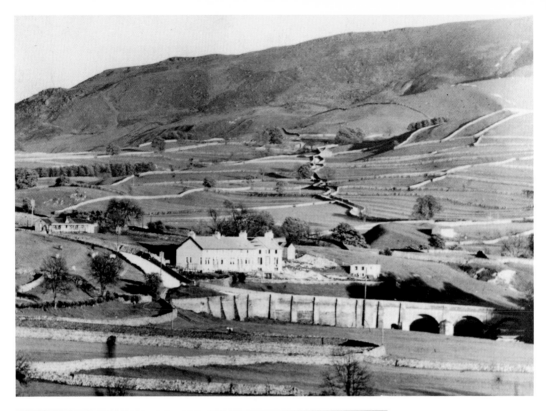

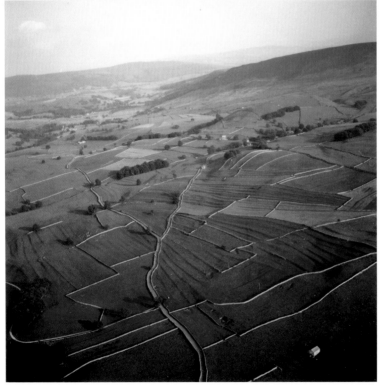

Field Systems
This photograph from the outskirts of Grassington, looking towards Burnsall and Thorpe, is very old and shows these fields with lynchets or terracing. They probably date back to medieval or even Romano–British times.

The view from the Cessna aircraft which I was flying in about 1990 shows just how many of these Lynchets there are.

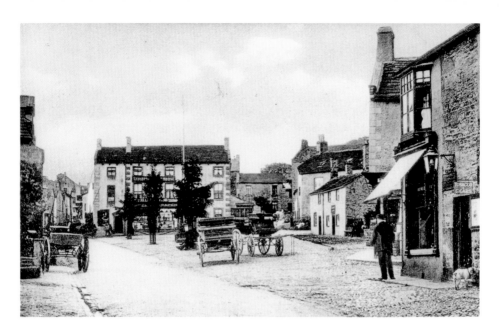

Grassington at Ground Level

About 100 years ago, it must have been a pleasant period in the centre of this popular village. There were no tourists and it was a real working village with a strong association with farming. It was very similar when I worked here in 1953 as a school dental officer with a mobile clinic. I had a very nice meal in the café seen at the top of the square, which was owned by Mr Darwin.

A few years ago I met a retired farmer who said 'when you were working at the school we called it G'ston, then it became Grassington, and now it's Graaasington!'

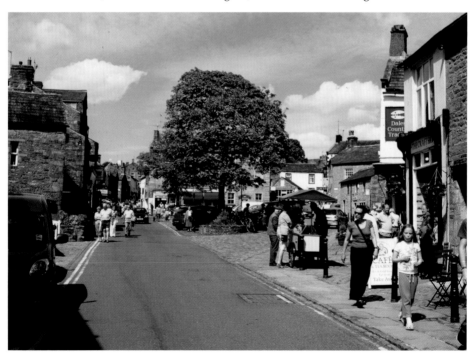

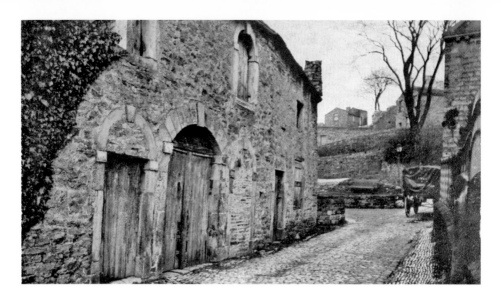

Side Streets of Grassington

There are plenty of streets to explore in Grassington, so an easy start is to walk up to the right from the square. According to the old photograph there was an old theatre here, which is now much altered.

Further up and round to the left is a street described on the postcard as an 'Old Roman Road'. The old postcard was loaned by Sarah Hughes.

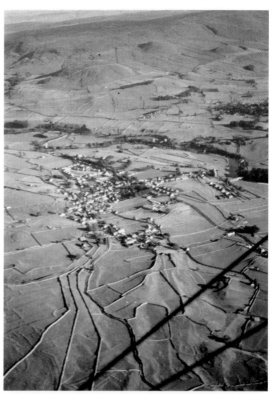

Grassington, as seen from a Tiger Moth in 1959

Here is the view of Grassington taken from the Tiger Moth I've previously mentioned – note the wires at the bottom of the picture. This is a good view of a much earlier Celtic field area, as well as Romano–British period [AD 200–400].

Flying behind this scene and over Grass Wood towards Coniston, we can see many remains of early habitation, such as a section known as 'Site A', thought to be Iron Age. Also visible is a pond and a line of bell pits from a much later age, perhaps Victorian.

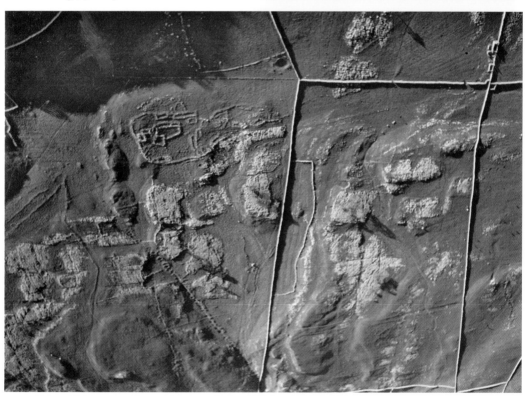

Conistone

From Grassington it is a short drive to Conistone, going by the back road that runs alongside Grass woods, or a very quick flight!

The scene today shows part of the village looking towards Conistone Moor, and there is a footpath running up towards the moor that crosses the Dales Way path

A view from above c. 1990.

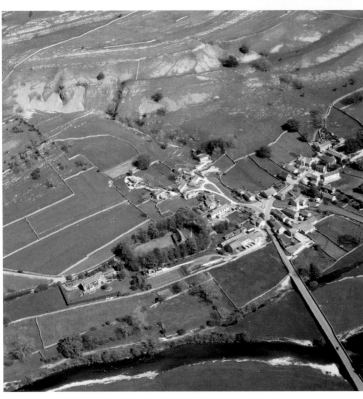

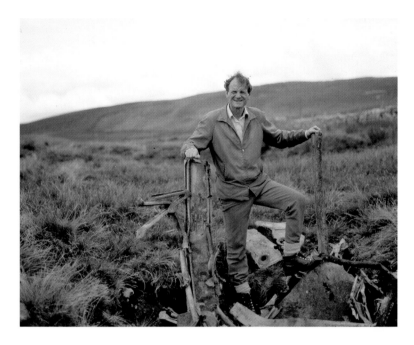

Vickers Wellington

Soon after the end of the Second World War, training was still in progress. A Wellington bomber took off from the Operational Training Unit at Silverstone (now the well known race track) with a new crew, heading north on a practice cross country flight. No one knows what happened but they crashed on Conistone Moor and there were no survivors. These photographs show the remains of the aircraft, still lying in the field where they fell.

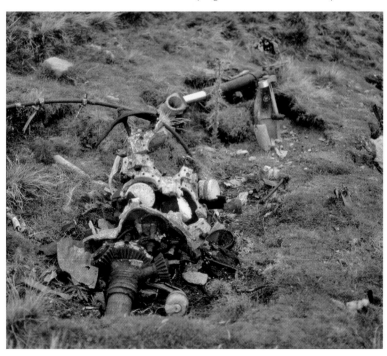

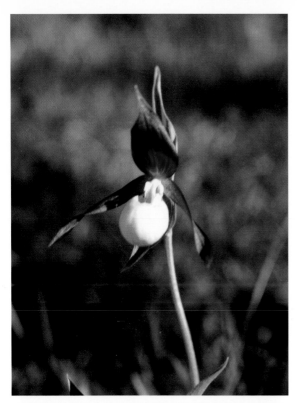

The Orchids
Just a few miles south of the Wellington crash site there are a few 'Lady's Slipper' Orchids on a well protected site. I think attempts have been made to propagate them.

Many years ago they were so plentiful that local people sold them to visitors. Now this is the only site in England where they are known to grow. These images were taken in 1975 and I have not seen them since.

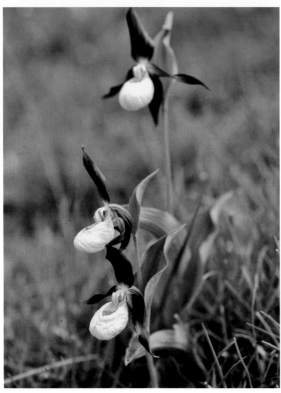

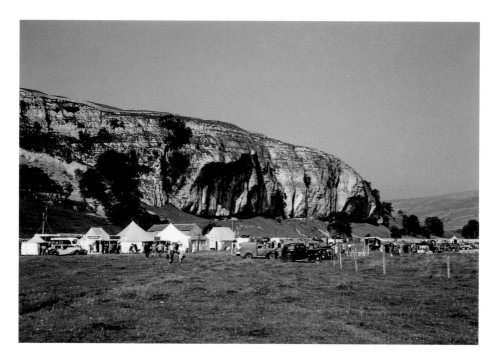

Kilnsey Show

Held every year at the end of August, this is a very popular show and the site is dominated by Kilnsey Crag, a well-known beauty spot and a site of geological importance. It is part of the Craven Fault, but more about that later.

The old photograph was taken in 1953 when my wife, Kathleen, and I came to live and work in Skipton. Since then the show has grown enormously and is a lot more commercial. Here is a view taken in 2010.

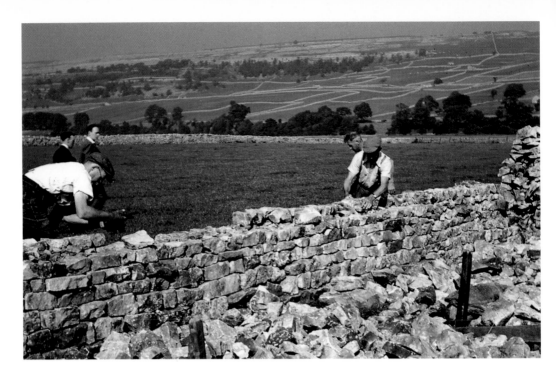

Kilnsey Show Stone Wall Competition

A section of the wall is pulled down and each contestant is allocated a section that he or she has to rebuild.

Here is part of the wall in 1953, the waller on the left is Mr Ellwood from Kendal. The new image depicts some wallers in August 2010, and the weather is just as good.

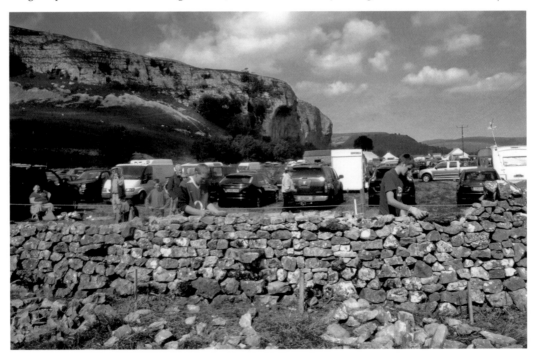

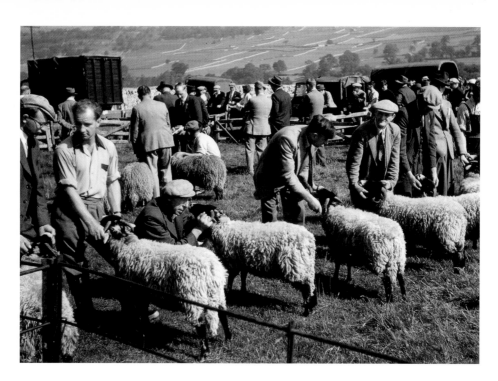

The Line Up of Swaledale Sheep

Lawrie Whitehead, Jack Alderson (kneeling) and Brain Fawcett are three of the Swaledale farmers depicted in this image from 1953.

In 2010 Swaledale sheep are still brought to the show for judging and the judges are twins.

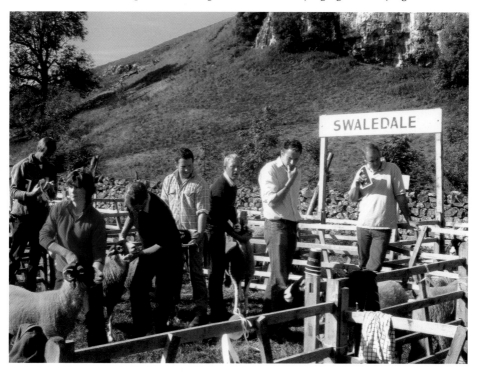

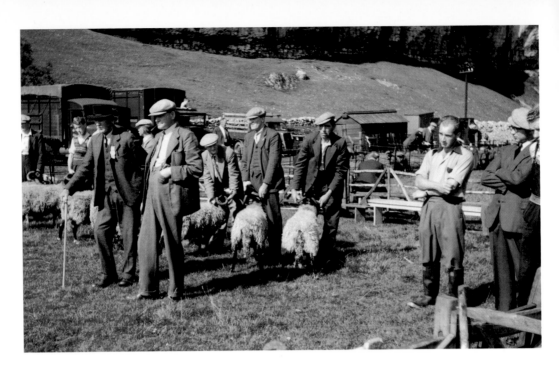

Kilnsey Show

Another picture of Swaledale judges wanting to see one of the sheep moving before awarding the prizes – a study in concentration.

There's 'no sweat' in the second picture as the winning Dales cob relaxes with the first prize card on its neck. Kathleen is also enjoying a day at the show in 1953.

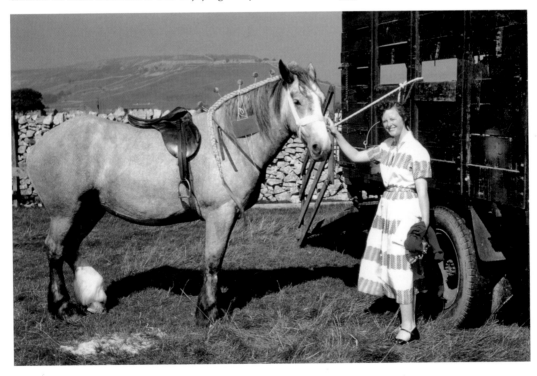

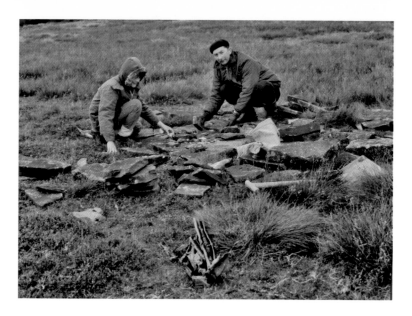

Joe Fusnik

Joe was the rear gunner of another Wellington that crashed during a cross country exercise. He was the sole survivor when they hit the top of Walden Moor on the side of Buckden Pike. They were lost in a snowstorm so conditions were grim when he managed to get out of the wreck. Joe says that he followed the trail of a fox across the side of the mountain. He had a broken ankle and was lucky when he found the White Lion Inn at Cray, where he was taken in by the Parker family.

In about 1972 Joe returned to build a monument to his fallen comrades. Our son John and me helped to build the base, but realised more skill was needed so I asked my friend Harry Smith to help. The farmer brought up the cross in his Land Rover.

Mrs Spink was the daughter of the Parker family who rescued Joe on that bleak night, and she was there at the completion of the monument.

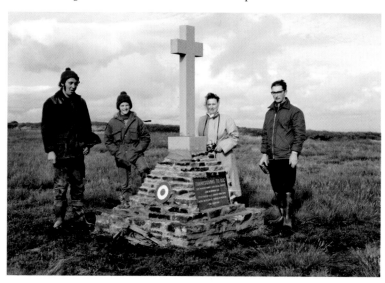

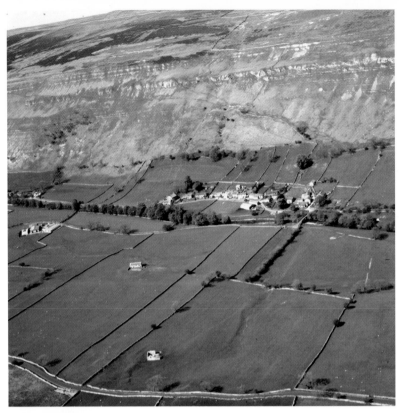

Hawswick
A pretty village on the way up Litton dale. One day I cycled along the valley and took a rest on a bridge, where I watched a fly-fisherman casting onto the rapids and I remarked on the lovely scene. He replied, 'It's paradise here.'

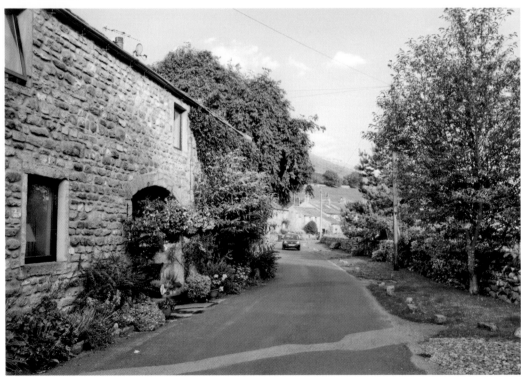

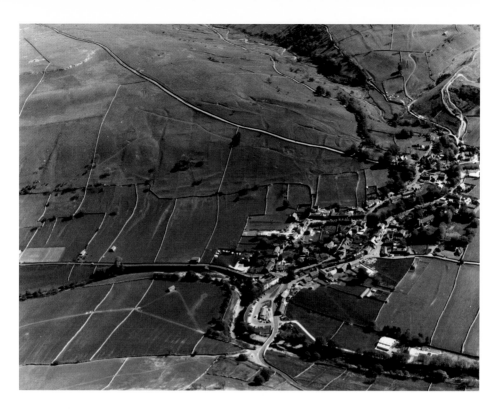

Kettlewell

A short flight over the moor above Hawswick and we get this view of Kettlewell, which I photographed in the late 1980s.

Recently the villagers have been campaigning to save their school from the threat of closure and I have just heard that they have been successful.

Kettlewell is famous for its annual Scarecrow show so I wasn't surprised when I saw these children with their cook and head teacher displaying a 'Save our School' banner.

In the late 1950s I worked at all the schools in the area as school dentist and made many friends. The children were delightful to know and I often see them now, grown up and with families of their own.

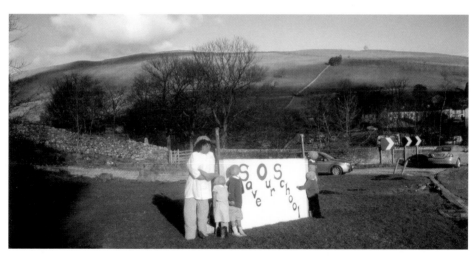

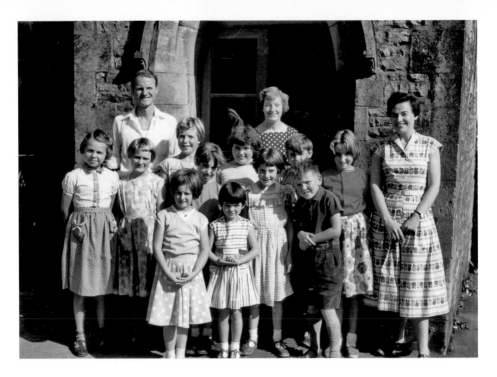

Arncliffe School

A very short flight takes us to this pretty, unspoilt village. There is a small school and in 1959, on a visit as school dentist, head teacher Miss Riley lined up the children, I set the self timer on my camera, moved round to join my dental nurse, Barbara Wood, and waited. This was the result. Notice the lad in front, evidently in fear of something!

We are not allowed to photograph children now, so the teacher in 2010 agreed to pose.

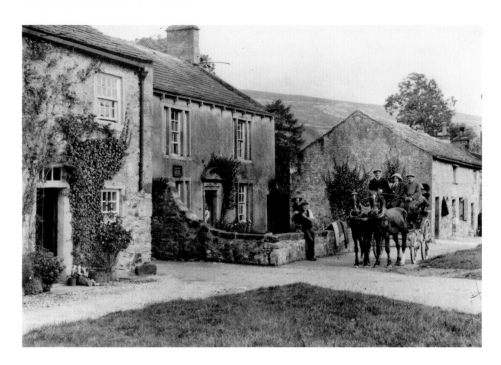

Arncliffe on the Green

This is Joe Ibbotson, a carrier, who could deliver anything and also make sure people caught a train – he was also the post master. With him is Jim Jowett the Clog-maker.

A narrow road to the left, between the houses, leads to the bridge over the Skirfare and also to the church of St Oswald.

The view today in 2010.

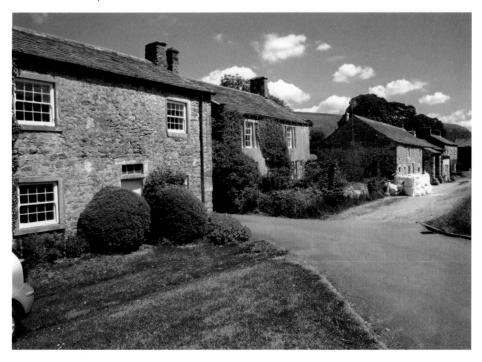

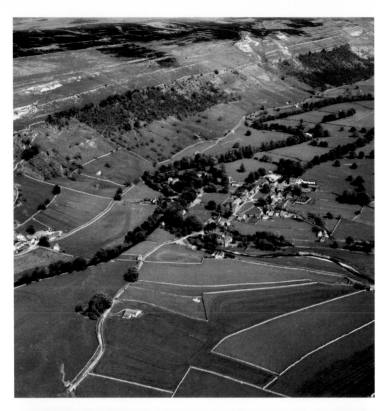

Arncliffe from Above

A most unspoilt village which has farms within its boundary. In spring the grass on the green is allowed to grow and later is cut for hay.

The village sits next to the river Skirfare, which is crossed by a beautiful bridge, and nearby sits the lovely church.

High up on the fell-side there are the remains of much earlier habitations, which are well documented by such experts as Dr Raistrick, who did a lot of work in this area.

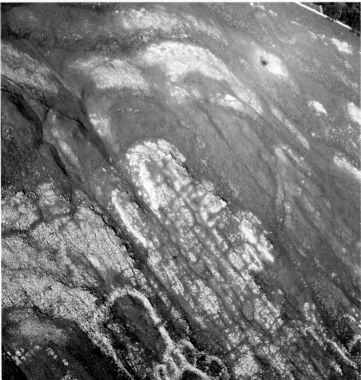

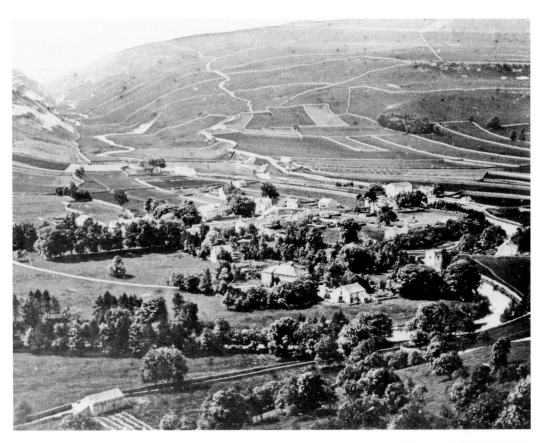

Arncliffe from the Hillside

This view shows the drive to what was the original vicarage. There is also a very clear view of the valley and road to Darnbrook. Cowside Beck runs down this valley into the river Skirfare.

The view in colour was taken 16 May 1989 and is almost the same today. Both photographs show the roads on each side of the valley.

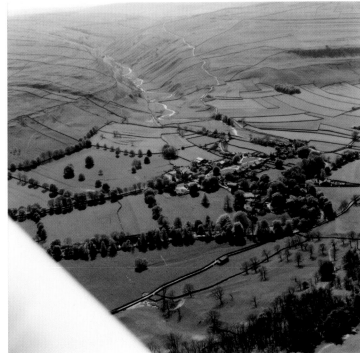

Mrs Gill, Postmistress, Arncliffe

Here is Mrs Gill outside her cottage in Arncliffe. I enjoyed many a visit here, to have a chat about times past, but I am afraid to say she is no longer with us and is sadly missed by her many friends in the Dale.

Inside her cottage she is sitting next to her vintage fire-range, which she kept in immaculate condition. It is one of Manby's ironmongers of Skipton. Manby's closed many years ago, but they are featured in my other books about Skipton.

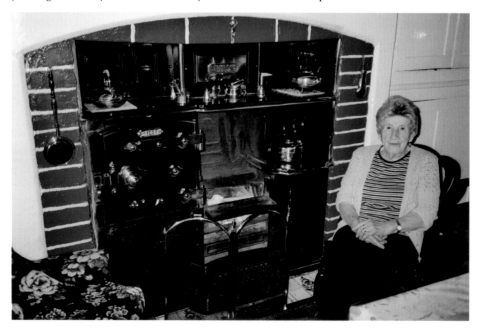

Litton

Taking the road up the Dale we come to Litton, where we get this view of the entrance to the village, the Queens Head Inn comes into sight.

The village lies just nicely elevated, out of the valley bottom. There is some good agricultural land to be seen.

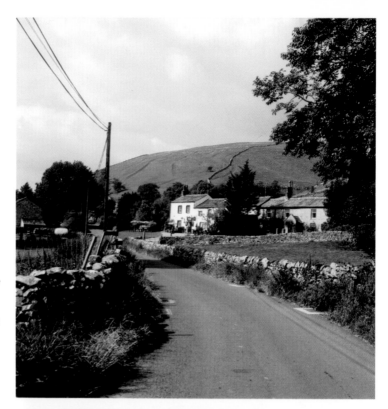

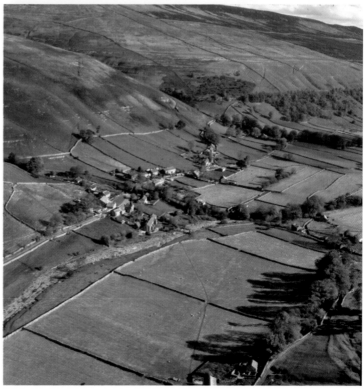

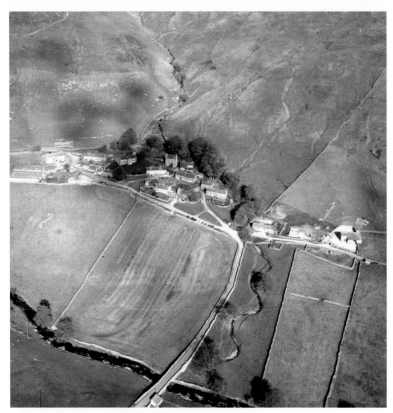

Halton Gill

After leaving Litton we are soon at Halton Gill, where there is a road branching off, which passes over the south side of Pen-y-Ghent, one of the three peaks of the well known race which also takes in Whernside and Ingleborough. The road continues into the market town of Settle, which lies in Ribblesdale.

Note the large village green, also seen in the next photograph at ground level.

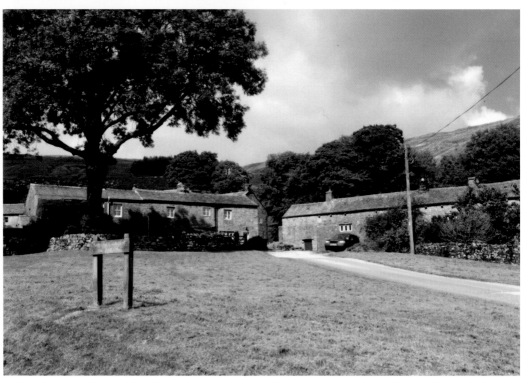

Foxup

This remote hamlet is situated at the end of the road up Litton dale and is reached very quickly by air – the road, however, is very narrow. There was more activity on the farms in the 1980s, although when Kath and I went up there in September 2010, Foxup Bridge farmers were very busy haymaking.

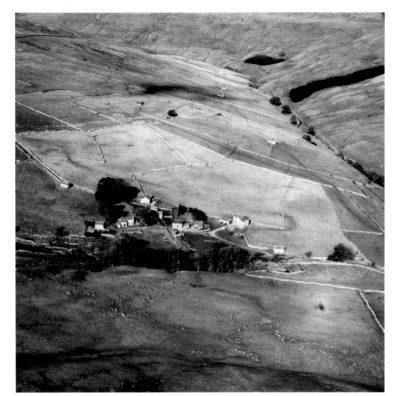

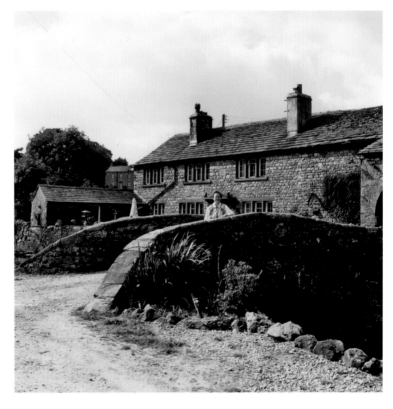

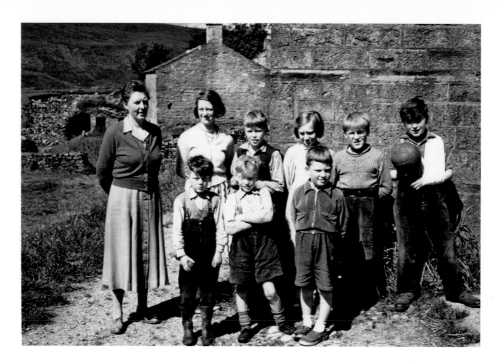

Oughtershaw School

Here is the school where I worked as dentist in the late 1950s. Miss Wood and I spent a few days here with the dental caravan and as there was no electricity, I had to use the foot engine.

Miss Ormorod is seen here with the children who lived at the outlying farms – they had a bit of walking to do to get to school.

We were invited to school dinner and we all walked across the road to a farmhouse where auntie Annie sat us all down to a real farm dinner!

The building looks like an old chapel now and is not very well cared for.

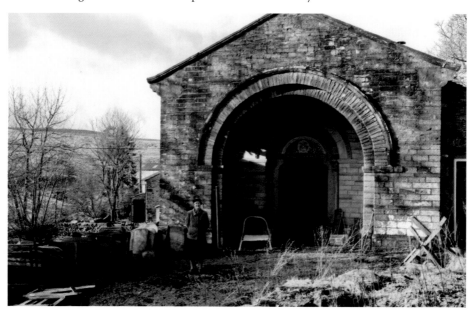

Ribblehead Viaduct

After a few more minutes of flying north-west, this fantastic structure comes into view. In a distant corner of the picture one can see Pen-y-Ghent.

The viaduct carries the Settle–Carlisle railway and there are many excellent books about its construction and indeed the whole line to Carlisle.

After crossing the viaduct the trains plunge into Blea Moor tunnel and emerge into Dentdale.

Ingleborough can be seen beyond the viaduct.

To the right rises Whernside and this is the third of the three peaks of the famous race run each April – 28 miles and 3 mountains to climb over 2,000 feet.

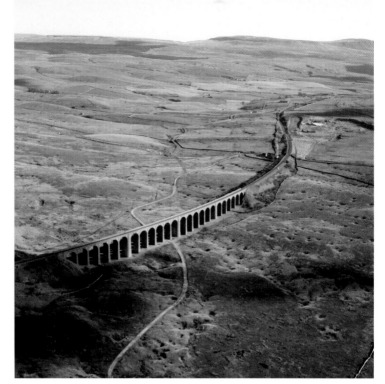

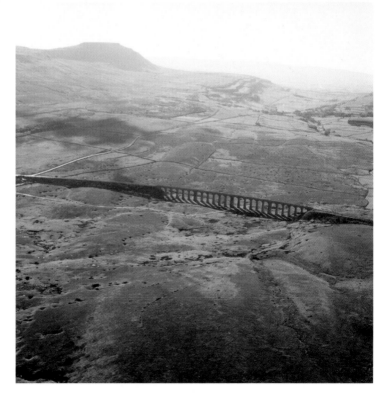

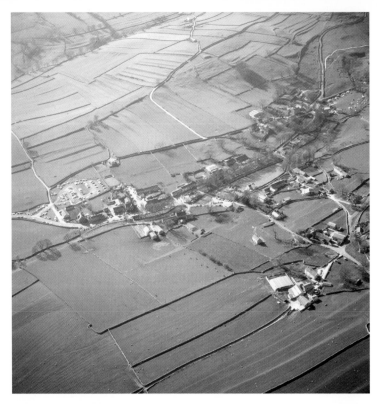

Malham

A beautiful flight following the railway line to Settle and then the road gives views over superb scenery, such as Attemire Cave. The journey is much slower by road, but is just as interesting and scenic, and affords one a chance to see one of the special steam trains attacking the 'long drag'.

In 1938 I visited Malham with the City of Leeds school and we climbed past the waterfall at Gordale Scar and onto Malham Tarn. Our geography master, Mr Crowther, pointed out the large slate bridge and said 'this is the secret of Malham Tarn, the bottom is composed of slate otherwise the water would drain away through the limestone'.

The modern image shows the Skipton Band crossing the bridge at Malham about halfway through a sponsored march of thirty villages to raise band funds.

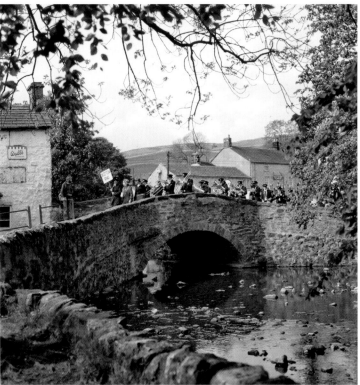

Malham Cove to Gordale Scar

A lovely place to visit and explore, with a good Information Centre next to the car park. A visit in spring could be rewarding because a pair of Peregrine Falcons nest there – they are beautiful to watch, although passing pigeons do not think so!

A short flight past the Cove and we begin to get a view of Gordale Scar.

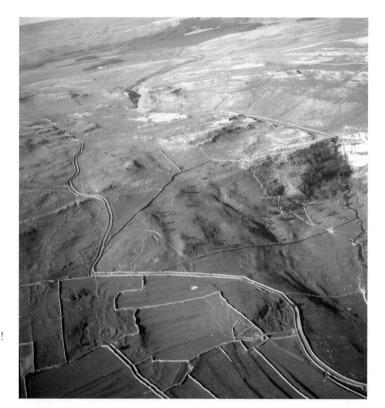

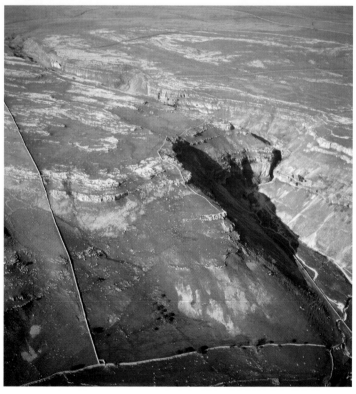

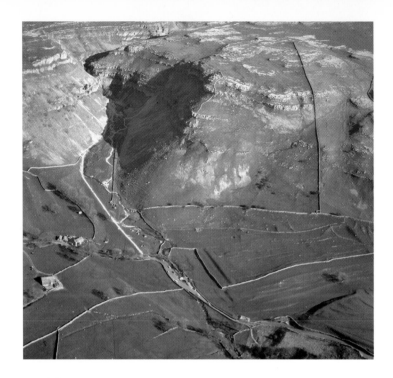

Gordale Scar

Turning north and following the beck that runs into Gordale, we can see a faint rectangle in the ground, it is the remains of a Roman marching fort, designed for 100 men – Mastiles Lane, a footpath from Kilnsey to Malham, can be seen to pass through it. Thousands of walkers must have passed through the fort without knowing it, because there is not much evidence on the ground.

After the first sight of the Scar, one is not disappointed when the main view of the cavern comes into view, quite spectacular.

It is thought that this was once a cave with a roof, which had fallen in. Round the corner in the shade there is a waterfall.

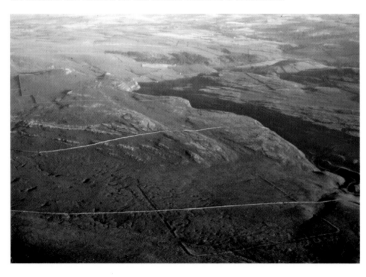

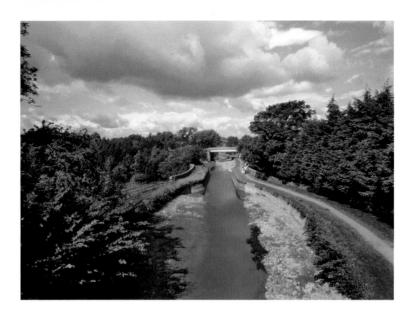

Banknewton

The river Aire rises at Malham Tarn but soon goes underground and emerges at Aire Springs just south of Malham. Following the river down and into Airedale, we soon arrive at Banknewton where, especially from the air, we can see where the railway crosses the Leeds & Liverpool canal, the road, and the river Aire. The canal also crosses the river but runs under the road.

A view of the canal in 2010 – because of the drought, the water level could not be maintained as the top-up reservoir was almost empty.

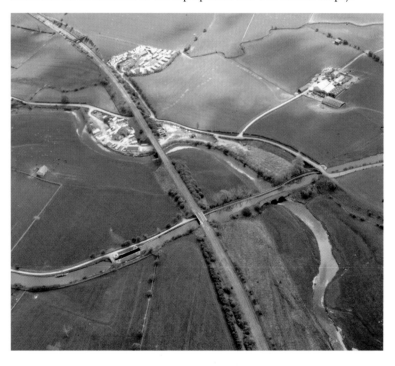

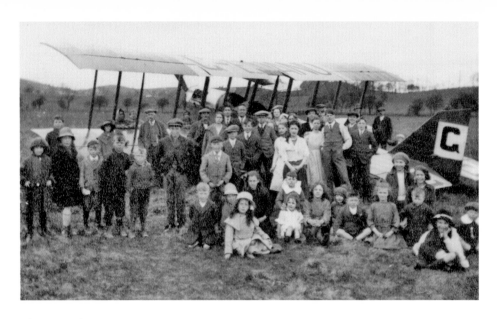

Also at Banknewton

In the early 1920s an aircraft landed here, probably lost or short of fuel. Many of the residents of Gargrave went along to see it. The code letters on the top wing are illegible, so identification is difficult.

The photograph in August 2010 shows the only large field, which is probably where the aircraft landed.

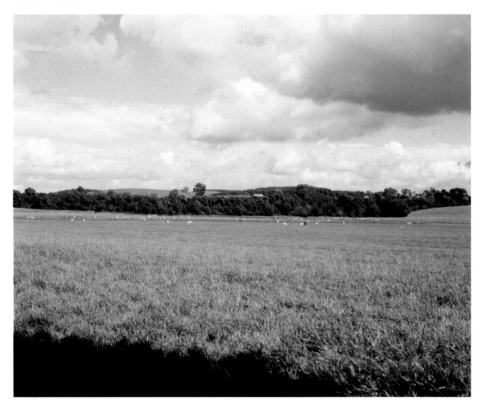

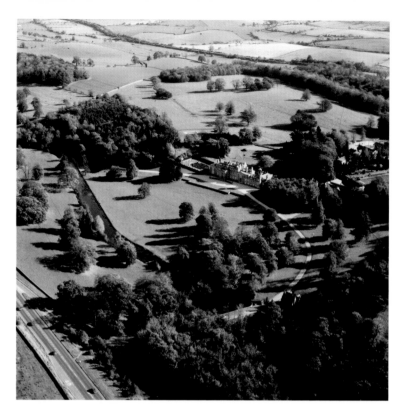

Broughton Hall
This is the ancestral home of the Tempest family, who have resided here for many centuries. As times have now changed, Roger Tempest and his team have carefully converted many of the buildings for modern use.

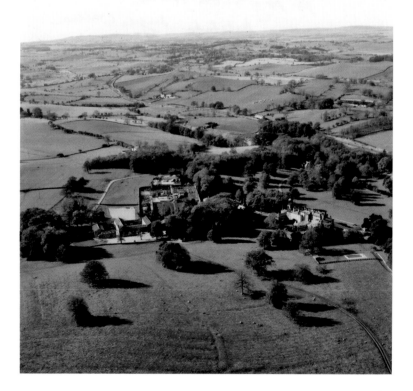

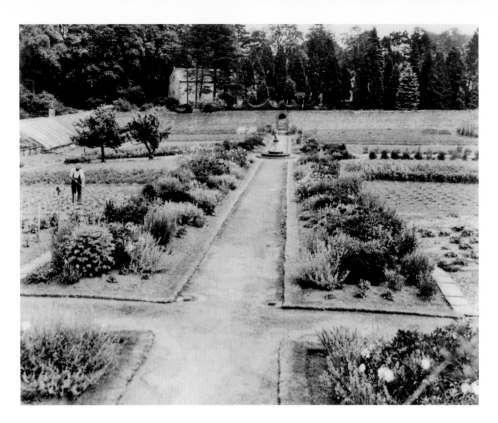

Utopia
The garden, when it supplied vegetables for Broughton Hall. A very modern restaurant has been built in the extensive garden, traditionally surrounded by a high wall, part of which was heated so that certain exotic fruit trees could grow alongside.

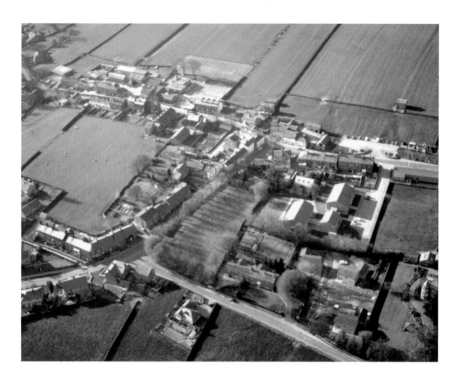

Embsay

A short distance out of Skipton and heading back to the aerodrome at Leeds, we pass over Embsay and can see the school (top left) and part of Main Street (right). Down at the station is the home of the preserved steam railway where the voluntary work force have re-laid the track to Bolton Abbey Station. Visitors are welcome and there is a café at each end – the ride between is very enjoyable.

I include this picture to show two visitors who have left their mark on Skipton. Dr Rowley – solicitor and author of books about Skipton – and Peter Black – who had a shoe factory in the town. They are admiring an early car from Peter's collection, which he had brought along for the vintage weekend.

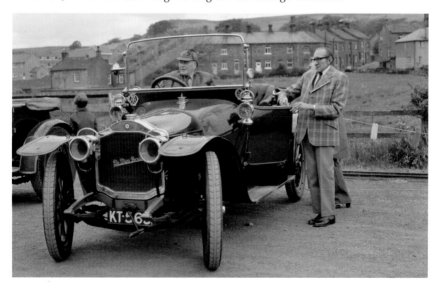

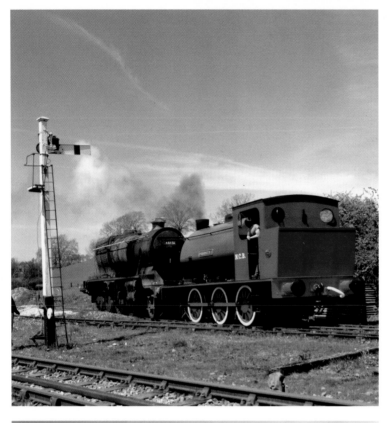

Embsay Station

This is the home of the Yorkshire Dales Railway, or Embsay & Bolton Abbey Steam Railway, and you can see one of their locomotives shunting the remains of a British Railways 8F. The members cleaned off as much rust as possible and then the owner, Mr Smith, who owns West Coast Railways, took it away to be rebuilt. It is now in splendid condition and goes out on tour, as does the locomotive in the next picture.

This is the *City of Wells* heading a train out of Skipton, on its way to Carlisle. The driver was Eddie Altham, a good friend of mine who worked for British Railways.

Also in view is Dewhirst's mill chimney, which was demolished some time ago. This image was on the front cover of one of the popular steam railway magazines.

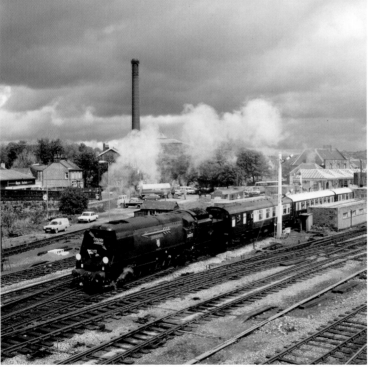

Another Day, Another Flight

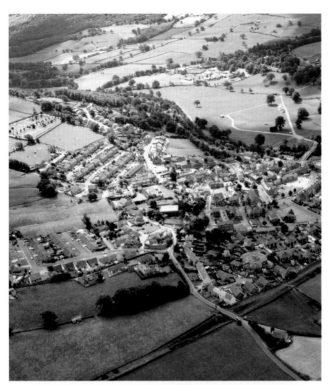

Starting with Pateley bridge we follow an ecclesiastical route to visit some well known abbeys in these Dales. Pateley Bridge lies on the hillside, the main street sweeping down to the river Nidd, on the other side of which can be seen the show ground that hosts the last agricultural show of the season. There is a very interesting museum in the town where visitors can learn about the Dale.

A short flight to the east and about eight miles distance we see one of the most outstanding examples of Cistercian architecture – Fountains Abbey.

It lies in the grounds of Studley Royal and the owner, William Aislabee, used the ruin in his landscape garden. He turfed the surrounding fields and made the best preserved of all the abbeys in England into the finest of picturesque ruins.

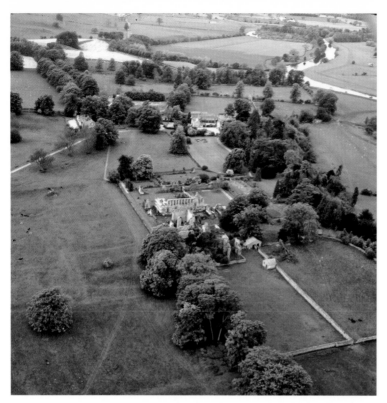

Jervaulx Abbey & East Witton

Flying north-west or driving by car via Ripon and Masham we come to Jervaulx Abbey, which was started near Aysgarth and moved to Jervaulx in 1156. The grounds are well looked after, but are not as finely groomed as Fountains Abbey, creating a natural effect. The river Ure is in the distance.

About a mile west lies the village of East Witton, which has the fine church of St John Evangelist, as well as an interesting layout of houses around the green.

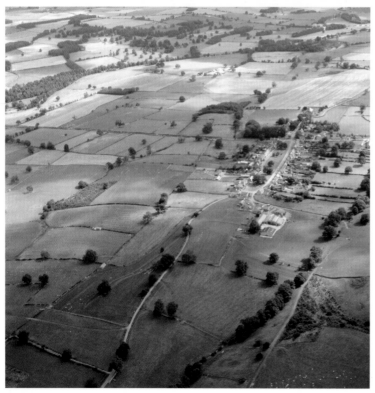

Middleham & Wensley

Still flying north-west we arrive over Middleham and are rewarded with a splendid view of the town and the castle, which, according to Pevsner, was built to guard the road from Richmond to Skipton. This town is well worth a visit and has a great association with racing.

A further 3 miles north-west is the village of Wensley, where there is a very important church, Holy Trinity, full of interest and associated with the Scrope family.

The bridge over the Ure has four arches and is an important crossing point.

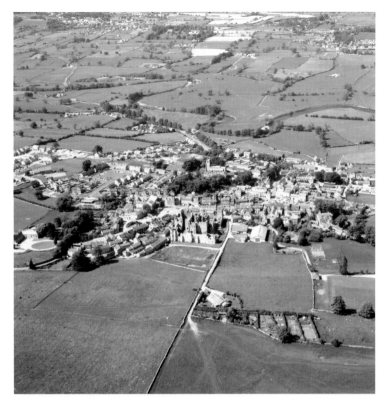

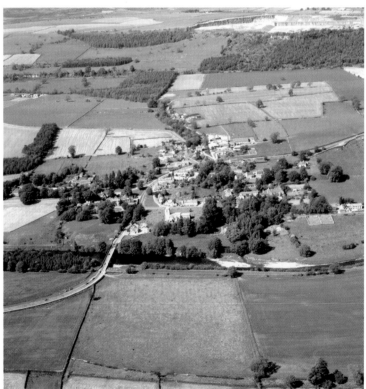

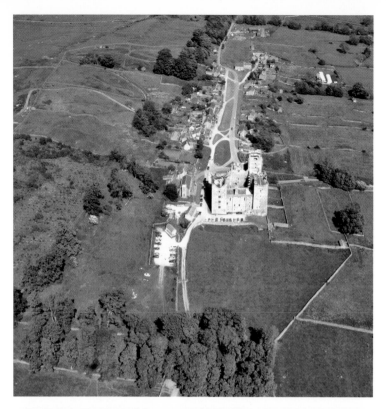

Bolton Castle

The castle was built by Richard de Scrope, who obtained licence to crenelate in 1379. The castle was intended to guard Wensleydale.

There are rooms to visit and a café with good food and also a shop. All in all one can have a good day out by visiting this fine castle in a beautiful dale.

Also the railway is in the process of being re-built. Originally this line left Northallerton and joined the Leeds–Settle–Carlisle main line at Garsdale.

Hawes Station is just out of reach as yet, and is a museum of the Dales life, begun by Marie Hartley and Joan Ingleley.

Marie was a good friend to me and lived to be a hundred years old. She was an author of books on life in the Dales.

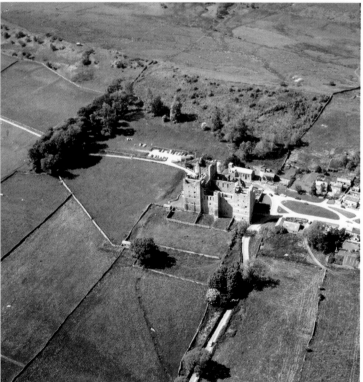

Hardraw Force near Hawes in Wensleydale

Many years ago a Brass Band Contest was held every year in this dell, between the pub and the waterfall, known as Hardraw Force. I think the Second World War was the reason the contest was discontinued.

Our conductor, Ken Bright, had the idea of taking the Skipton Band to play there once more and it sparked off the plan of rejuvenating the old contest again.

This idea grew and soon a committee planned a contest to be held annually. In fact Skipton won the first two or three contests, and then retired to let other bands have a chance.

Here are pictures of the Skipton Band taking part in the old original bandstand, and also at the waterfall not far away.

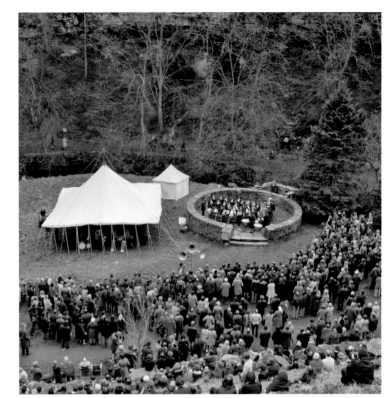

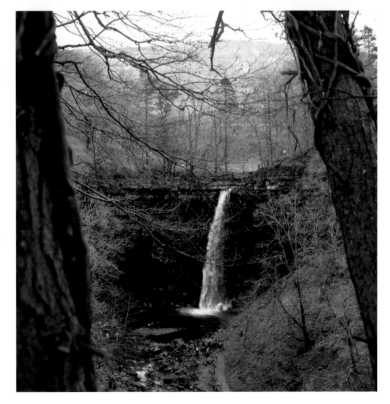

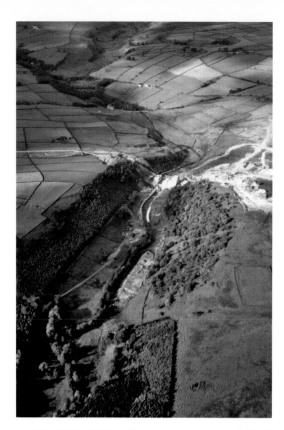

The Washburn Valley
The Washburn Valley was flooded to make the Thruscross reservoir. Here the valley can be seen both before and after the flooding.

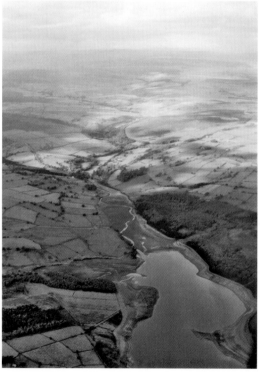

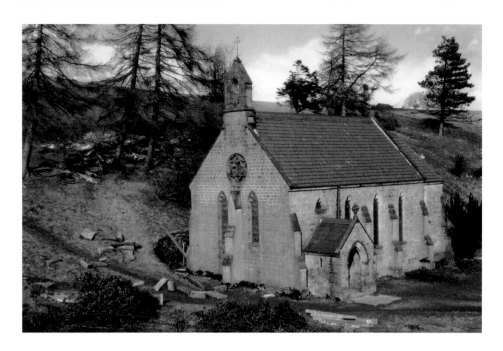

West End Church

When I heard that the upper Washburn valley was to become a reservoir, I decided to walk up the valley with our second son, John, who was four at the time (1964), and take some photographs. It was a beautiful valley and we explored the old mills and then the West End Church.

A trial flooding of the valley was done before the church was demolished. The graves had already been moved and are now in a small cemetery next to the Greenhow–Blubberhouses road.

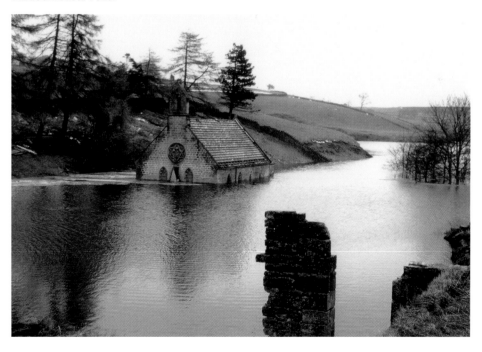

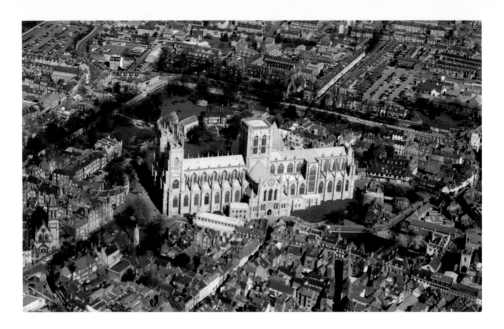

York Minster

In early April 2000 I heard that all the scaffolding had been removed from York Minster. On 6 April I took off in my Tiger Moth and, under the control of Church Fenon RAF, took this picture.

York is east of the Dales and situated on the river Ouse, which takes much of the water drained from here, hence large floods which part of York seems to get. The minster is safe on higher ground.

The Tiger coming in for a 'three pointer' after a photographic mission, captured by Mike Sweet.

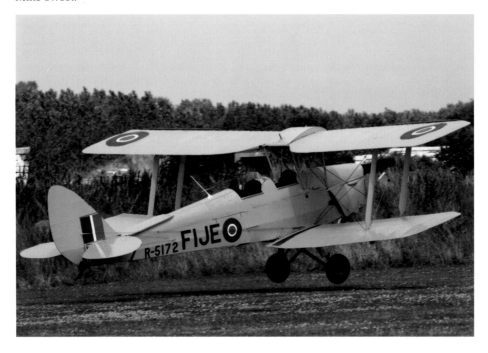

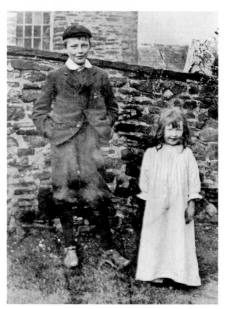
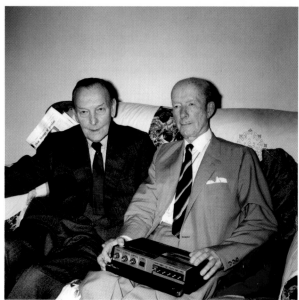

Herbert Smith, Aircraft Designer

To end this book I would like to pay tribute to Herbert Smith, who lived in Skipton and is seen here as a boy with his sister. He designed all of Sopwith's fighting aircraft, such as the Camel, Triplane and Snipe, used by the Royal Flying Corps during the First World War.

Born in Bradley in 1899, he attended the local school before going on to Keighley Grammar School and then Bradford Technical College, where he was awarded a diploma in mechanical engineering. Eventually he joined the Sopwith Aviation Company and eventually became Head Designer.

Just before I met Herbert Smith in Skipton I was a founder member of the Northern Aeroplane Workshop, which started with an advert in the *Yorkshire Evening Post*. It was placed by John Langham of Harrogate, who wanted to form a group of people interested in retaining the skills of the early aeroplane builders.

It was soon after this that I was introduced to Herbert and he came to many meetings, wholeheartedly supporting the idea of building his Sopwith Triplane. Sadly this took many years to build and neither he nor John Langham saw it fly. He is remembered in Skipton by a plaque on the Town Hall. On the right of the colour image is Warren Kay, who was a Sopwith Triplane pilot in the First World War.

Acknowledgements

Frank Knowles started copying for me as far back as 1970 and is still willing when occasionally I find something new.

Tony Harman at his shop in Newmarket Street can also copy, enlarge and transfer images onto disc.

People such as Donald Smith and Anne keep offering me undiscovered material, which is always exciting to me. Many people who offered old photographs have passed away, but I often think about them.

Craven Stationary have been very helpful in supplying folders to keep my photographs together.